SHELTON STATE COMMUNITY
COLLEGE
JUNIOR COLLEGE DIVISION
LIBRARY

DISCARDED

TR
287
.N28

Nadler, Bob.

The advanced b & W
darkroom book

DATE DUE			
NOV 20,'80			
JUL 22'81			
AUG 19'81			
MAR 4 '82			
OCT 6 '83			
NOV 18 '83			
OCT 3 1 1988			
JAN 13 '91			
MAY 29 '91			
OCT 09 '92			

SHELTON STATE COMMUNITY
COLLEGE
JUNIOR COLLEGE DIVISION
LIBRARY

DISCARDED/

D1170771

THE ADVANCED B&W DARKROOM BOOK

by BOB NADLER

DISCARDED

f/22 Press Leonia, New Jersey

Copyright © 1978, 1979, by Bob Nadler.

Published in Leonia, New Jersey, by *f*/22 Press. All rights re-
served. No part of this book may be reproduced in any manner
whatsoever without the written consent of the publisher.

Book design and production by Cook and Wolf, Inc.

Manufactured in the United States of America.

Library of Congress Cataloging in Publication Data

Nadler, Bob.
 The advanced b & w darkroom book.

 1. Photography—Processing. I. Title.
TR287.N28 770'.28 79–9934
ISBN 0–933596–00–6

INTRODUCTION

At some point in every darkroom worker's career, when the basics of normal film development and simple printing techniques have been mastered, he or she inevitably begins to wonder, is that all there is? I assume you have reached that point. It is a critical point, because it immediately precedes the discovery of a truly bewildering and often quite frightening array of darkroom techniques, products, and procedures.

The results of this sudden confrontation are sometimes disastrous. Severe feelings of doubt and inadequacy may set in and freeze the poor worker dead in his or her tracks. That is truly sad, because much of what is most awesome and seemingly impossible to master is of the least use to the vast majority of photographers. Unfortunately, most photographers who have just reached this level of darkroom processing awareness are still far too inexperienced to appreciate this peculiar state of affairs.

I prepared this book with all of that in mind. It is a simple guide to only those advanced darkroom processes, materials, and procedures that I have determined offer maximum image enhancement in return for the time, effort, and dollars invested. This book does not contain information on exotic, often arcane, techniques of manipulation; nor does it deal with procedures borrowed from the graphic arts. Instead, it offers logical, useful, and practical advanced extensions of basic black-and-white darkroom techniques. These go a long way toward improving the quality of the finished images that emerge from your darkroom and an equally long way toward making your life in that darkroom considerably easier. In addition, several of the techniques offered will help you to save images which you

may have believed were impossible to print.

The book is divided into two parts. The first deals with film processing, and the second with paper processing. Each of the sections within the parts can be dealt with individually. This is not the type of book that you must, or even should, read from front to back, cover to cover, to get the most out of it. If you are confronted with a thin, flat, hard-to-print negative and you think that negative intensification will help, simply turn directly to the section that specifically shows you how to undertake negative intensification. However, if you have never heard of negative intensification, or many of the other topics covered here, it might not be a bad idea to scan the book at least once, all the way through. In that way you will familiarize yourself with all the possibilities covered here, and you will begin to appreciate where some of the techniques discussed fit in the overall scheme of things.

You may have noticed that I said that this book will **show** you how to undertake negative intensification. It does. This introduction is one of the very few places in the book where paragraph after paragraph of text appears. For the most part this book consists of photographic illustrations, each with a short caption, which allow you to actually see each step, no matter how simple, along the way of every process or procedure described. I believe that this is the least boring, most useful way to convey needed information quickly. It eliminates ambiguity and confusion, as it literally **shows** you what to do and how to do it.

In keeping with this style of presentation and my efforts to keep the data offered as simple and uncluttered as possible, I've deliberately offered little information on the almost limitless number of

alternative methods and materials available to darkroom workers to achieve any particular photographic result. The information given here deals with only those methods and materials which, through a long period of experimentation, I have found to be satisfactory, useful, or, at the very least, better than nothing at all. I have done this because the world abounds in photographic materials. Some of the makers of proprietary items maintain that their products have characteristics unlike all others and can provide you with results otherwise unobtainable. I've tried many such proprietary products, but I've found very few that lived up to the claims made for them. Film developers are a case in point. I really don't know of any film developer that is better, or even cheaper, than D-76 (1:1). I don't know of **any** film developer that can provide you with an increase in film speed over the film manufacturer's ASA rating. Yet claims of superior film development characteristics are common among makers of proprietary film developers. The claims most often made for proprietary developers are: finer grain, higher acutance, and often higher effective film speed. The only way that you can convince yourself that you are not missing anything by sticking to D-76 (1:1) is to try several of the large number of proprietary developers available. To make that easier for you I've selected two excellent ones, Microdol-X and Rodinal, which I have found **do** have properties that differ considerably from D-76. I'll suggest several ways in which you may use them to advantage and offer several recommendations by which you may vary nega-

tive contrast. I'll also explain how you can "push" process your Tri-X film to achieve an apparent (but not real) increase of 1 or 2 stops in film speed. The developer I'll use for this purpose is good old standard D-76 (1:1).

I feel much the same way about Tri-X film as I do about D-76 developer. There is really very little that you can't do with Tri-X. However, there are a few jobs that slower, finer-grain films can do just a bit better. So I will offer data on the development of an excellent pair of fine-grain films, Kodak's Panatomic-X and Plus-X, over a wide range of temperatures. I'll offer the same time/temperature data for Tri-X as well, because few amateur darkroom workers have heated and air-conditioned darkrooms, and many of us are just too lazy or too pressed for time to control chemical temperatures accurately during film development. The formula I'll offer will enable you to use most developers at any temperature between 60°F (16°C) and 80°F (27°C). However, if math is not your thing, you might well skip this section.

Since we all make mistakes, I'll also show you how you can save some of your badly exposed or processed negatives by means of chemical intensification or reduction.

I have prepared this book on the assumption that you have read and understood the material in the first volume of this series, **The Basic B&W Darkroom Book**. Although I will not go over the same basic material, I will, wherever it is applicable and advantageous, refer to that data here.

The information in the book is presented in the following order:

Part I Manipulating Negatives

FILM DEVELOPERS AND DEVELOPMENT

1. This combination of materials, **Tri-X** and **D-76**, is excellent for virtually any photographic job you may ever want to do. But there are a few tasks which may be better served by some other product.

2. For example, this combination of materials, **Tri-X** and **Microdol-X**, is useful when you are willing to sacrifice a bit of film speed (about ½ to 1 full stop) in exchange for negatives with ever so slightly finer grain and ever so slightly higher acutance (sharpness) than you can get with D-76. Microdol-X can also be used with slower, finer-grained films, but there is little practical advantage to be gained.

3. Experienced darkroom workers most often find Microdol-X to be useful rather infrequently and then only for some special application. It is ideally packaged for this sort of use, in tiny foil packets that make 4 U.S. fluid ounces of stock solution. Unopened, these packets have several years of shelf life.

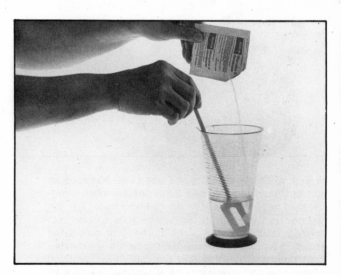

4. Microdol-X stock solution is most conveniently prepared immediately prior to use. Simply add the contents of the foil packet to 4 ounces (118 ml) of water at 120°F (49°C) and stir until the chemicals are dissolved completely and the solution is uniform.

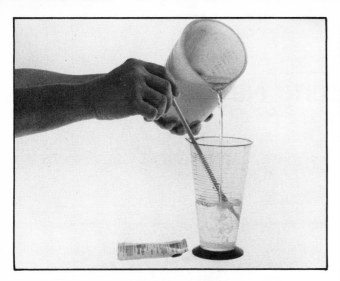

5. Now add sufficient cold water (distilled, if you have experienced problems with your water supply in the past) to bring the volume of the working-strength (1:3) developer solution to 16 ounces (473 ml) and the solution temperature to 75°–80°F (24°–27°C).

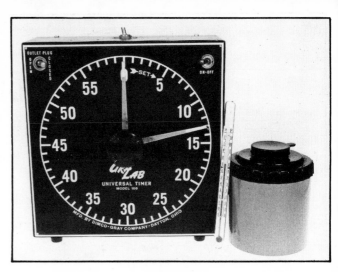

7. For developing Tri-X in Microdol-X at the 1:3 dilution, 75°F (24°C) is the ideal processing temperature. A developing time of 13 minutes (using the agitation schedule and techniques offered in **Basic B&W Darkroom** will ordinarily provide negatives of normal contrast. Only a narrow range of temperature, 75°–80°F (24°–27°C), is satisfactory for the use of this developer at this dilution. **Do not use it at any temperature below this range.** All other processing steps should be carried out at the same temperature, ± 1°F (± ½°C), used for development.

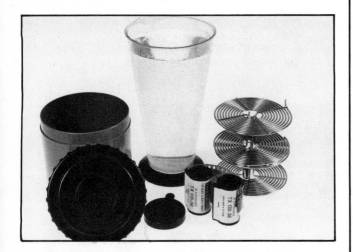

6. Best results will be obtained when one 36-exposure roll of 35mm film (or two 20-exposure rolls) is developed in 16 ounces (473 ml) of Microdol-X (1:3) developer. However, two 36-exposure rolls can be processed in this volume if the nominal or calculated times, to be given later, for development are extended by 10 percent. Microdol-X at this dilution can be used **only once** and then **must be discarded**. Replenishment is not possible.

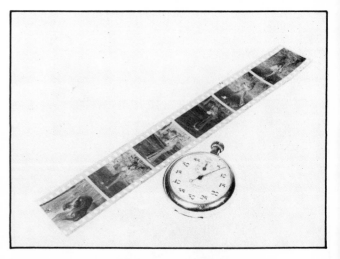

8. You can control **negative contrast** with this developer, as with D-76 and most others, by **varying the development time** for any given temperature. Increase the nominal or calculated development time by 40 percent to get about one paper grade more contrast. Decrease it by 40 percent to lower contrast by about one paper grade.

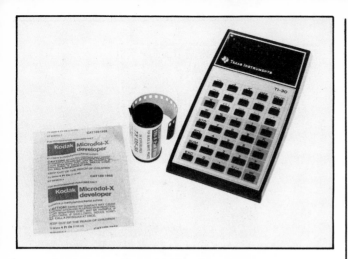

9. Later in this text (Figures 25–36), I will offer a general formula for finding nominal development times, for any temperature between 60° and 80°F (15° and 27°C), for several of Kodak's films and developers.. However, since the range of useful temperatures of Microdol-X (1:3) is so limited I have precomputed the values useful with Tri-X and offer them here in tabular form:

DEVELOPER TEMPERATURE		DEVELOPMENT TIME* (IN MINUTES)		
°F	°C	Normal Contrast	Lower Contrast	Higher Contrast
75	24	13	8	18
75.5	24.25	12.5	7.5	17.5
76–76.5	24.5–24.75	12	7	17
77–77.5	25–25.25	11.5	7	16
78–78.5	25.5–25.75	11	6.5	15.5
79	26	10.5	6.5	15
79.5–80	26.25–26.75	10	6	14

*Rounded to the nearest half-minute.

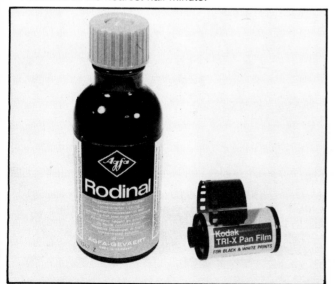

10. This combination of materials, **Tri-X** and **Rodinal**, yields very grainy negatives, which can produce beautiful prints. Rodinal produces very sharp, hard-edged silver grains, which many photographers and darkroom workers find adds aesthetically to the image.

11. Rodinal is sold as a concentrated liquid. It, too, is probably best used for special applications. Unfortunately, the smallest quantity sold is this 100-ml bottle. Fortunately, the concentrate keeps well in the partially filled original bottle for up to about 6 months.

12. A **10-ml glass graduate** (available from any scientific equipment or chemical supply house, or from a cooperative druggist) is very useful for working with Rodinal.

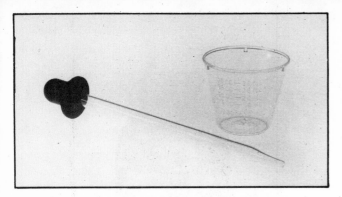

13. You can also use a **30-ml plastic graduate** (available cheaply at any drugstore) if you are careful. With either type of graduate you'll find that a long **eyedropper** (also available at any drugstore) is a very handy thing to have.

15. If you use a 30-ml graduate, be sure it is on a level surface. Have your eyes at the same level as the ¼-ounce line when measuring the volume of concentrated Rodinal. (These graduates have no 1-ml calibration marks. The ¼-ounce mark is used because ¼ ounce equals almost exactly 7.5 ml.)

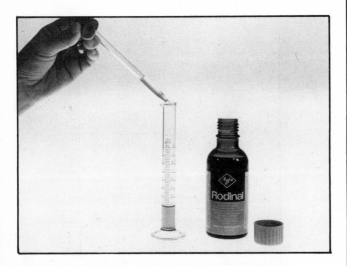

14. Remove the concentrated solution from the Rodinal bottle with the eyedropper and add it drop by drop to the graduate until you have ¼ ounce (7.5 ml) in the graduate. Don't get Rodinal on your hands if you can avoid it. It can cause stains, or rashes, or worse.

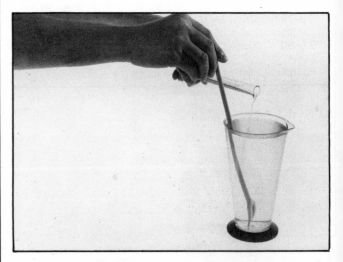

16. Measure 17 ounces (500 ml) of **water** (use distilled water if you have had difficulties with your tap water in the past) at 68°F (20°C). Then pour the Rodinal concentrate from the small graduate into the water in the large graduate, and stir until the solution is uniform.

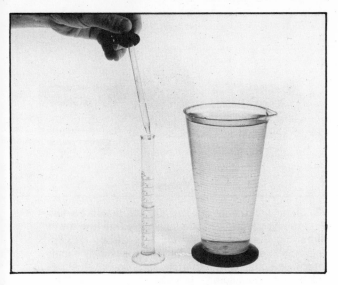

17. Use an eyedropper to transfer some of the 1:67 working-strength solution you have just mixed from the 500-ml graduate into the 10-ml graduate, and then pour it back into the 500-ml graduate. Do this 2 or 3 times to be sure that you have gotten all of the Rodinal concentrate out of the 10-ml graduate.

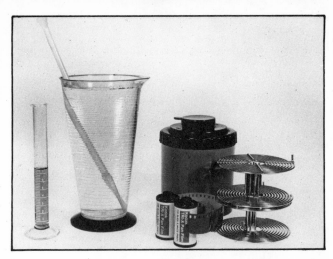

19. Best results are obtained at this 1:67 dilution when only one 36-exposure roll (or two 20-exposure rolls) of 35mm film is processed in a 500-ml tank. However, you can obtain satisfactory results when processing two 36-exposure rolls at a time in a 500-ml tank by adding 10 percent to the nominal processing time.

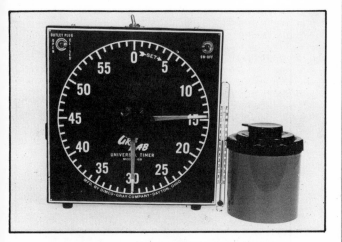

18. When developing Tri-X in Rodinal at the 1:67 dilution, 68°F (20°C) is the ideal processing temperature. A developing time of 14½ minutes (using the agitation schedule and techniques offered in **Basic B&W Darkroom**) will ordinarily produce negatives of normal contrast.

20. Because the major component of this developer is water and because it is mixed just prior to use, it is easy to bring its temperature to 68°F (20°C). However, if necessary, a range of temperatures 65°–72°F (19°–21°C) can be used with appropriate processing-time compensation (use the formula offered in Figure 25 and a D value of 44). All other film processing steps should be carried out at the same temperature, ±1°F (±½°C), used for development.

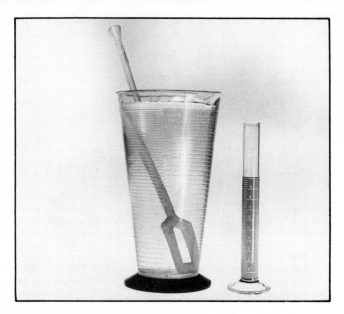

21. With this developer you control **negative contrast** in a rather peculiar way—by regulating the developer **dilution.** To increase contrast, keep time and temperature constant but increase the working-strength solution concentration to 1:50 (mix ⅓ ounce [10 ml] of Rodinal into 17 ounces [500 ml] of water).

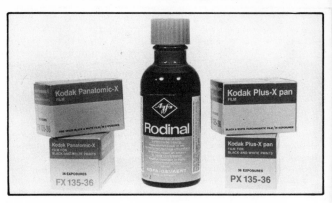

23. Some photographers and darkroom workers like the extremely high acutance obtainable with **fine-grain films** and **Rodinal.** Finding the right dilution and developing times for these combinations is usually a matter of personal experimentation. However, the developer's manufacturer, Agfa-Gevaert, Inc., 275 North St., Teterboro, N.J. 07608, will supply suggested processing data upon request.

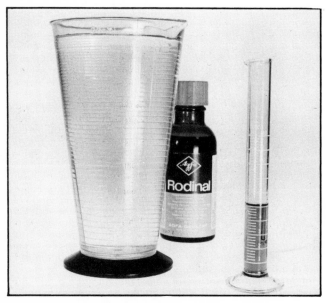

22. To decrease negative contrast, hold time and temperature constant and decrease the working-strength solution concentration to 1:100 (mix ⅙ ounce [5 ml] of Rodinal into 17 ounces [500 ml] of water).

24. These slow, fine-grain films are often best when you know that you'll have plenty of light to shoot with (or a sturdy tripod, a cable release, and a still-life subject) and you intend to make enlargements at greater than 12× magnification. Such films are often a good choice for black-and-white copy work.

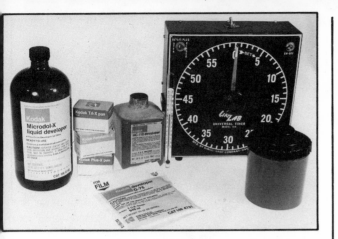

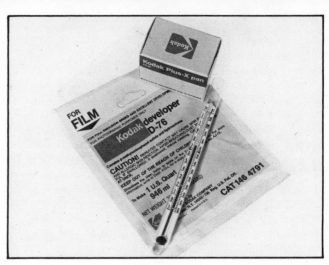

25. It is possible to process any of these films in any of the following developers over a range of temperatures 60°–80°F (16°–27°C) through the use of a relatively simple **formula** to determine the appropriate nominal developing time. The formula follows:

Developing time (in minutes)

$$= \text{Antilog} \left[\frac{D - (15 + \frac{dT}{2})}{25} \right],$$

where D is a number to be found in the table below and dT is the difference (in **Fahrenheit**) between 68°F and the desired processing temperature. dT is positive for temperatures above 68°F and negative for temperatures below that point. Antilog simply means "the number whose logarithm is equal to the sum in the brackets." Log^{-1} is a shorthand notation for antilog that I'll use in the calculations to follow:

D VALUES

35mm & Roll-Film Types	Developer Types and Dilutions				
	D-76 1:1	D-76	HC-110 Dil. B	Microdol-X	Microdol-X 1:3*
Tri-X Pan	40	37.5	36.5	40	46
Plus-X Pan	36.5	33	32	36.5	42.5
Panatomic-X	36	32	30.5	36	42

*Microdol-X (1:3) should not be used at temperatures below 75°F (24°C).

26. Solving this equation is relatively quick and easy with a **table of logarithms** and pencil and paper, and quicker and easier with a scientific-type **pocket calculator.** Suppose, for example, you want to process a roll of Plus-X in straight D-76 and the room temperature as well as the stock-solution temperature is 74°F. To find the nominal development time begin by finding the value of D to be 33 from the table under Figure 25. Next, find the value of dT. dT = 74 − 68 = 6. Now put the values of D and dT into the formula and solve the developing time:

Developing time (in minutes)

$$= \text{Log}^{-1} \left[\frac{33 - (15 + \frac{6}{2})}{25} \right]$$

$$= \text{Log}^{-1} \left[\frac{33 - (15 + 3)}{25} \right]$$

$$= \text{Log}^{-1} \left[\frac{33 - 18}{25} \right]$$

$$= \text{Log}^{-1} \left[\frac{15}{25} \right] = \text{Log}^{-1} \, 0.6$$

27. To solve for the number of seconds needed for development you must now find the number whose logarithm is equal to 0.6. If you own a scientific calculator, consult its instruction booklet for the keyboard procedure to do this. With this machine the procedure to solve the simple algebraic formula above is to leave the value of \log^{-1} on the register (or enter the value 0.6).

29. Then press the log key and the answer, 3.98 minutes of development time, will appear on the register. The whole solution from beginning to end ought to take you about 1 minute to calculate.

28. Then press the INV (inverse) key.

Logarithms of Numbers										
N	0	1	2	3	4	5	6	7	8	9
10	0000	0043	0086	0128	0170	0212	0253	0294	0334	037
11	0414	0453	0492	0531	0569	0607	0645	0682	0719	07
12	0792	0828	0864	0899	0934	0969	1004	1038	1072	1
13	1139	1173	1206	1239	1271	1303	1335	1367	1399	07
14	1461	1492	1523	1553	1584	1614	1644	1673	1703	17
15	1761	1790	1818	1847	1875	1903	1931	1959	1987	20
16	2041	2068	2095	2122	2148	2175	2201	2227	2253	2
17	2304	2330	2355	2380	2405	2430	2455	2480	2504	25
18	2553	2577	2601	2625	2648	2672	2695	2718	2742	2
19	2788	2810	2833	2856	2878	2900	2923	2945	2967	2
20	3010	3032	3054	3075	3096	3118	3139	3160	3181	3
21	3222	3243	3263	3284	3304	3324	3345	3365	3385	3
22	3424	3444	3464	3483	3502	3522	3541	3560	3579	3
23	3617	3636	3655	3674	3692	3711	3729	3747	3766	3
24	3802	3820	3838	3856	3874	3892	3909	3927	3945	3
25	3979	3997	4014	4031	4048	4065	4082	4099	4116	4
26	4150	4166	4183	4200	4216	4232	4249	4265	4281	4
27	4314	4330	4346	4362	4378	4393	4409	4425	4440	4
28	4472	4487	4502	4518	4533	4548	4564	4579	4594	4
29	4624	4639	4654	4669	4683	4698	4713	4728	4742	4
30	4771	4786	4800	4814	4829	4843	4857	4871	4886	4
31	4914	4928	4942	4955	4969	4983	4997	5011	5024	5
32	5051	5065	5079	5092	5105	5119	5132	5145	5159	5
33	5185	5198	5211	5224	5237	5250	5263	5276	5289	5
34	5315	5328	5340	5353	5366	5378	5391	5403	5416	5
35	5441	5453	5465	5478	5490	5502	5514	5527	5539	5
36	5563	5575	5587	5599	5611	5623	5635	5647	5658	5
37	5682	5694	5705	5717	5729	5740	5752	5763	5775	5
38	5798	5809	5821	5832	5843	5855	5866	5877	5888	5
39	5911	5922	5933	5944	5955	5966	5977	5988	5999	5
40	6021	6031	6042	6053	6064	6075	6085	6096	6	
41	6128	6138	6149	6160	6170	6180	6191	6201	6	
42	6232	6243	6253	6263	6274	6284	6294	6304	6314	
43	6335	6345	6355	6365	6375	6385	6395	6405	6	

30. If you don't own a calculator, consult a log table to find that the number on the right of the decimal (6) corresponds to the value 39.8 in the table. The number to the left of the decimal is 0, which tells you to move the decimal point one place to the left to give you the value of the developing time as 3.98 minutes, which is equal, for all practical purposes, to 4 minutes.

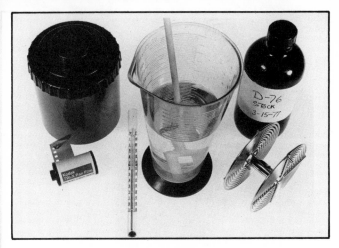

31. Let's try another sample problem, this time finding the development time needed for Tri-X in D-76 at a 1:1 dilution, working in a cold darkroom at 62°F. Begin by finding the value of D in the table (in Figure 25) to be 40 and the value of dT to be equal to $-(68-62) = -6$.

33. Now use the calculator to find the number the log of which equals 1.12. First push the INV button.

32. If you own a calculator use it to solve the equation:

Developing time (in minutes)

$$= \text{Log}^{-1}\left[\frac{40 - (15 + \frac{(-6)}{2})}{25}\right]$$

$$= \text{Log}^{-1}\left[\frac{40 - (15 - 3)}{25}\right]$$

$$= \text{Log}^{-1}\left[\frac{40 - 12}{25}\right]$$

$$= \text{Log}^{-1}\left[\frac{28}{25}\right] = \text{Log}^{-1}\ 1.12$$

34. Then push the log button to find the answer to be 13.18 minutes.

35. Convert the 13.18 minutes into minutes and seconds. There are 60 seconds in a minute, so multiply 60 times 0.18 and add the product to 13 minutes. Your developing time is equal to 13 minutes and 10.8 seconds. For all practical purposes you would develop the film for 13 minutes and 11 seconds.

37. This formula can be used with the great majority of black-and-white developers. In order to find the D value for any developer all you need to know is the proper development time at 68°F (20°C). You can find the D value with the following formula:

$$D = 25 (\log M) + 15,$$

where M is equal to the proper development time at 68°F (20°C) in minutes.

	Logarithms of Numbers						
N	**0**	**1**	**2**	**3**	**4**	**5**	**6**
10	0000	0043	0086	0128	0170	0212	0253
11	0414	0453	0492	0531	0569	0607	0645
12	0792	0828	0864	0899	0934	0969	1004
13	1139	1173	1206	1239	1271	1303	1335
14	1461	1492	15	1553	1584	1614	1644
15	1761	1790	18	847	1875	1903	1931
6	2041	2068	2095		2148	2175	2201
7	2304	2330	2355		2405	2430	2455
8	2553	2577	2601	2	8	2672	2695
	2788	2810	2833	285		2900	2923
	3010	3032	3054	3075		118	3139
	3222	3243	3263	3284	3		3345

36. If you have no scientific calculator, use a pencil and paper to get the value of the antilog, then consult a log table to find that the number closest to the digits to the right of the decimal (12) corresponds to a value of 13.2. The "1" to the left of the decimal indicates that the decimal is to be left as it stands. Conversion of the decimal value to seconds gives you the answer 13 minutes and 12 seconds. The discrepancy of 1 second is due to my lazy lack of interpolation in the table. This degree of inaccuracy (0.1 percent) is quite all right with a development period as long as 13.2 minutes.

38. For example: If your supersoup developer gives you negatives that print properly through a No. 2½ Polycontrast filter, or on a grade No. 3 paper, after 10 minutes of development at 68°F (20°C), the chemical's D value would be found by solving:

$$D = 25 (\log 10) + 15 = 25 (1) + 15 = 25 + 15 = 40$$

39. The ASA **speed rating** of a film is **not** affected by your choice of developer, regardless of the claims made by its manufacturer. Film speed is strictly a function of the **sensitivity of the silver salts** in the film's emulsion.

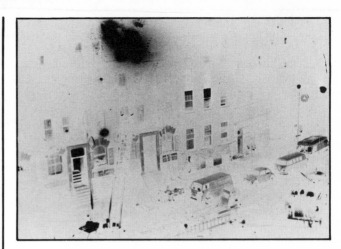

41. In situations where the light available is extremely dim and diffused, the scene contrast is very low, and there are no important details whatever in the shadow areas, it is possible to rate Tri-X film at E.I. 800 or 1600 and process it in D-76 (1:1) for 50 percent longer than your normal development time. You will get thin, grainy negatives like this one. There will be little or no shadow detail and the negatives will be hard to print. Do not expect to be able to produce good-quality prints from such negatives.

40. When film is exposed in dim, diffused, low-contrast light, it is often possible to rate it about 1 stop faster than its manufacturer does. Try shooting Tri-X under these conditions with an exposure index (E.I.) of 800 and then develop the film as you normally do. You will get thin negatives lacking detail in the shadow areas. Try printing the negatives on harder-than-normal grades of paper or with higher-than-normal Polycontrast filters. Don't expect to be able to make high-quality prints with them.

42. When you have no other choice, you can try rating Tri-X at E.I. 1600 or even E.I. 3200. The number you set on the film-speed dial will make little difference. The film will record only the highlight and middle-tone details bright enough to affect the emulsion and cause a latent image to be formed. Anything in shadow will go unrecorded. Process the film in D-76 (1:1) for 50 percent longer than you normally would. Expect exceedingly thin, grainy negatives, which will prove to be very difficult to print.

NEGATIVE IMAGE INTENSIFICATION

43. Don't be surprised if some images made at high E.I.'s turn out to be as thin as this one. You can try to rescue them with an **intensifier,** but even this won't work unless some important detail has recorded an image on the film. An intensifier can increase the **density and contrast** of the silver image on a negative, but it can't affect shadow areas of the scene that left **no** latent image on the film at all.

45. There are 2 component envelopes inside the Kodak Chromium Intensifier package, one marked A and the other marked B. Be careful when handling the A packet, which contains a very strong bleaching chemical.

44. If possible, **never** resort to any type of negative intensifier. Consider it only if there is no way to reshoot the subject and the negatives won't produce an image of good enough quality for use. Several intensifier formulas are available. **Kodak's Chromium Intensifier** is unique in that it is prepackaged, contains few poisonous ingredients (mercury types are particularly deadly), and produces an image that won't fade quickly. (Mercury intensifiers produce more unstable images, while silver intensifiers produce more stable images than chromium intensifiers do.)

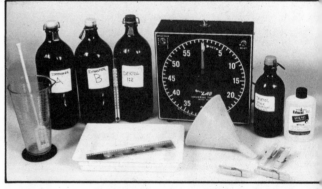

46. You will need few hardware items to intensify the image on a strip of negatives or even a single frame: a small, white, shallow **tray** and 4 plastic **clothespins.** The rest of the equipment needed is already in your darkroom: three 16-ounce (or larger) storage **bottles,** a **stirring rod,** a **16-ounce graduate,** a **funnel,** and a **thermometer.** You will also need some items of software already in your darkroom: 5½ ounces (163 ml) of **Dektol** developer stock solution and some **Kwik-Wet** wetting agent.

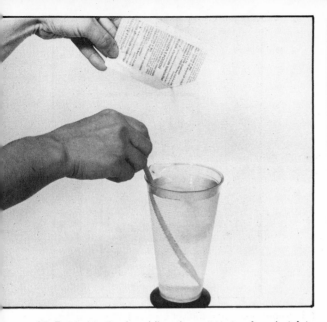

47. Begin by slowly adding the contents of packet A to 16 ounces (473 ml) of water at 68°F (20°C). Stir until the powder is dissolved. This may take some time.

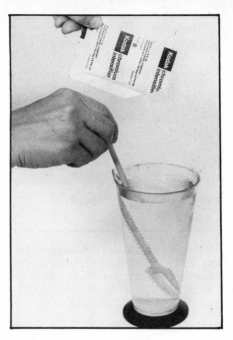

49. Slowly add the contents of packet B, the clearing bath, to 16 ounces (473 ml) of water at 68°F (20°C). Stir until the powder is dissolved.

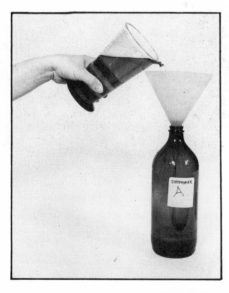

48. Pour the bleach bath into a glass container that you have labeled "Intensifier A," and put the bottle aside. Thoroughly wash the graduate, stirring rod, and funnel.

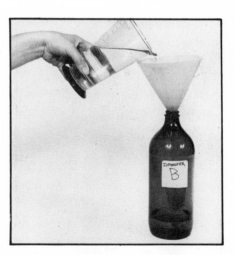

50. Pour the clearing bath into a glass container that you have labeled "Intensifier B" and put the bottle aside. Thoroughly wash the stirring rod, graduate, and funnel.

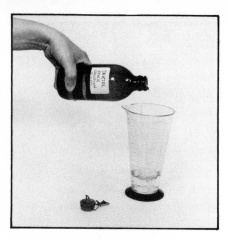

51. You will need some Dektol stock solution for this process. Pour 5½ ounces (163 ml) of Dektol stock solution (for mixing instructions see **Basic B&W Darkroom**) into a 16-ounce graduate.

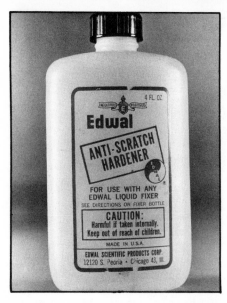

53. Before going any further be absolutely sure that the negatives you want to intensify are perfectly clean and that they were hardened when they were fixed. If you have any doubt, refix them in a fixing bath that contains the full recommended hardener (see **Basic B&W Darkroom**). All of the steps that follow are carried out in normal room light.

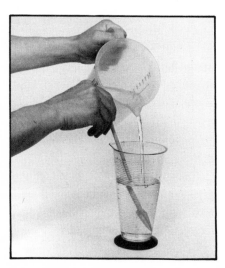

52. Add 68°F (20°C) water to the 16-ounce (473 ml) level, and stir until the Dektol working-strength (1:2) solution is uniform. Then pour the Dektol working-strength developer into a clean container. Thoroughly wash the graduate, stirring rod, and funnel.

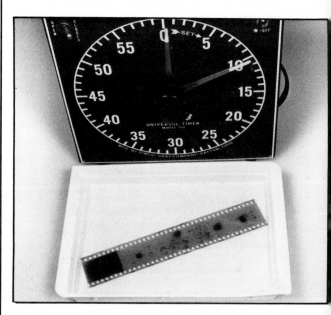

54. If the negatives to be intensified have been dried, place them, **emulsion side up,** in 68°F (20°C) water for 10 minutes. If the frames to be intensified are among normal negatives that you want to reprint, cut off the properly exposed and processed frames and remove them.

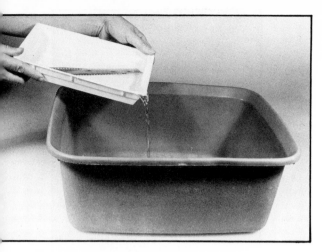

55. Carefully discard the presoak water, leaving the negatives in the tray.

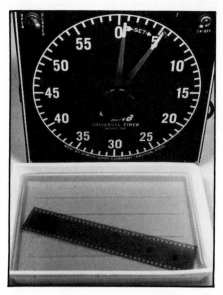

57. It normally takes between 3 and 5 minutes for the silver images on the negatives to turn yellow. Agitate gently but continuously during bleaching by rocking the tray.

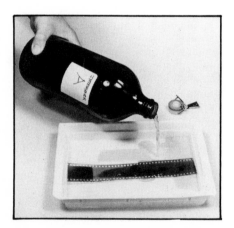

56. Pour the 68°F (20°C) bleach bath (A) over the negatives in the tray.

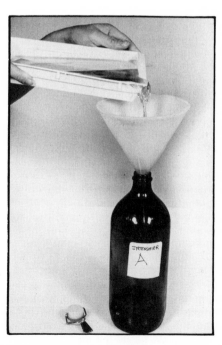

58. As soon as all of the silver has turned yellow, carefully pour all of the bleach bath back into its storage bottle, leaving the negatives in the tray. Wash the funnel thoroughly.

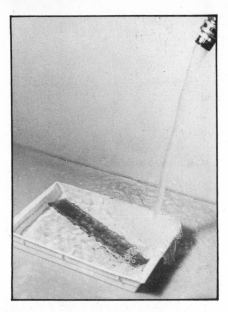

59. Wash the negatives in 68°F (20°C) running water for about 30 seconds, then carefully pour the water out of the tray. If running water is unavailable, use two 16-ounce (473-ml) changes of fresh water, allowing the negatives to remain in each change of water for 15 seconds before carefully discarding it. Leave the negatives in the tray.

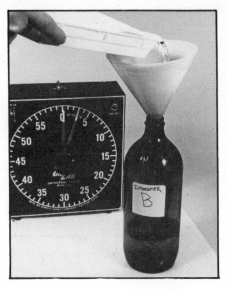

61. After the negatives have cleared, carefully pour the clearing bath into its storage bottle, leaving the negatives in the tray. Thoroughly wash the funnel.

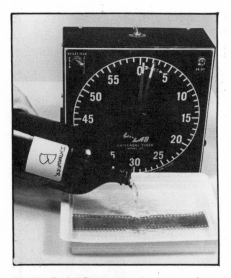

60. Pour the 68°F (20°C) clearing bath over the negatives in the tray. It will normally take about 2 minutes for the clearing bath to remove all the yellow stain from the negatives, leaving the film base clear and the image a light tan color. Agitate gently but continuously during the clearing by rocking the tray.

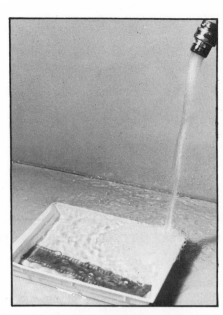

62. Wash the negatives for 1 minute in 68°F (20°C) running water, then empty the tray. If no running water is available, use **four** 16-ounce (473-ml) changes of fresh water, allowing the negatives to remain in each change of water for 15 seconds before carefully discarding it. Leave the negatives in the tray.

63. Pour the 68°F (20°C) Dektol working-strength developer into the tray. Allow the negatives to redevelop until all of the tan image has darkened. This should take about 2 minutes. Agitate gently and continuously during redevelopment by rocking the tray.

65. Wash the negatives for 20 minutes in running 68°F (20°C) water. If no running water is available, use a 16-ounce (473-ml) change of 68°F (20°C) water every 30 seconds for 25 minutes. When the wash has been completed, carefully pour the wash water out, still leaving the negatives in the tray.

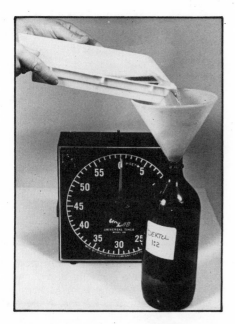

64. After the negatives have been completely redeveloped, gently pour the Dektol working-strength solution back into its storage bottle, leaving the negatives in the tray.

66. While the negatives are washing, prepare a wetting solution by adding 12 drops of Edwal's Kwik-Wet to 16 ounces (473 ml) of 68°F (20°C) water and stirring gently until the solution is uniform.

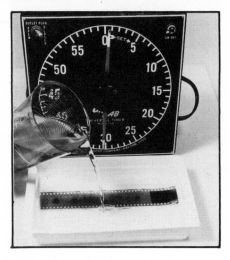

67. Set 30 seconds on the clock and start it. Pour the wetting solution over the negatives in the tray.

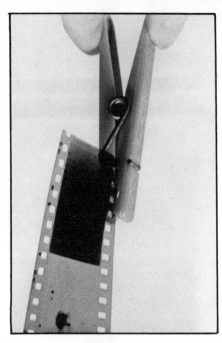

69. Hanging only a few 35mm frames up to dry without damaging one or two is virtually impossible with standard negative clips, but plastic clothespins can be used to do the job quite well. Attach them to the sprocket-hole areas at the top and bottom corners of the strip. They can be used the same way to hang a single frame.

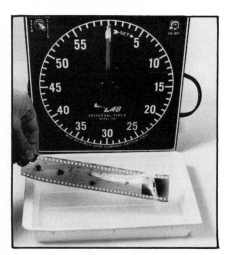

68. After the clock has run out, remove the negatives from the wetting solution and let the excess solution drip off. Be sure that the wetting solution **completely** covers the entire surface of the negatives. If it doesn't, the negatives will have to be washed for an additional 5 minutes, wiped with a photo chamois, and then reimmersed in the wetting solution for another 30 seconds.

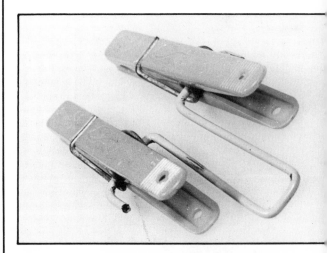

70. A homemade **hanger** (made with wire from a clothes hanger) enables you to hang the strip of negatives and prevents the clothespins from accidentally touching the emulsion area of the frames. A piece of string, tied between 2 upper clothespins, can also be used, but not as satisfactorily as the wire device.

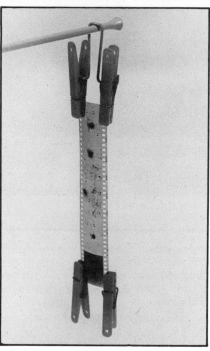

71. Hang the intensified negatives in a dust-free area and allow them to dry.

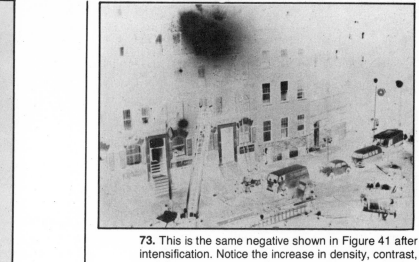

73. This is the same negative shown in Figure 41 after intensification. Notice the increase in density, contrast, and grain.

72. Check the dried negatives with a **loupe** to determine if you have gotten the degree of intensification you want. If not, you can repeat the entire process (Figures 54–71) all over again, for as many times as additional intensification is needed. But bear in mind that each time the process is repeated the **contrast and grain will both be increased.**

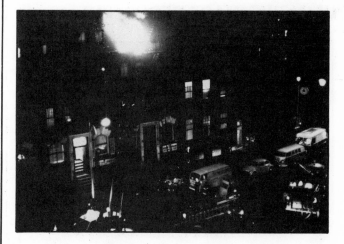

74. This print, on contrast grade No. 6 paper, was the best I could make from the **original** negative (Figure 41).

75. This print was the best I could make, on contrast grade No. 6 paper, from the **intensified** negative. On balance, intensification did nothing to improve this image, although it may help in some cases.

77. The negative shown here was properly exposed, but deliberately overdeveloped by 50 percent. Therefore it has proportionally more silver in the highlight areas than it does in the shadow areas and so it appears to be too dense and contrasty.

NEGATIVE IMAGE REDUCTION

76. If you haven't been discouraged by the preceding example of chemical correction for film-exposure problems, you may want to investigate negative **reduction.** There are 2 types of problems reducers can sometimes help correct: **overexposure** and **overdevelopment.** Overexposed film has too much silver deposited in all areas—highlight, middle tone, and shadow—of the image. The negative shown here was deliberately overexposed by 2 stops and then normally developed. It appears to be too dense and to lack contrast.

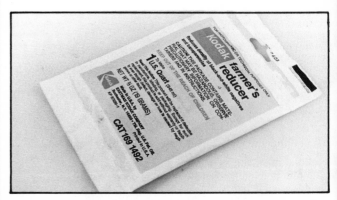

78. This prepackaged **Kodak Farmer's Reducer** can be used to alleviate overexposure problems. When used as a single-bath (Kodak Formula R-4a) cutting reducer, it removes nearly equal **quantities** of silver from highlight, middle-tone, and shadow areas of the negative image. This type of reduction (called "cutting") acts to **increase** negative **contrast** while **decreasing** image **density.**

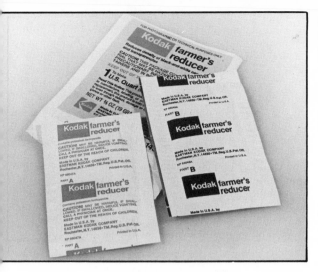

79. There are 2 small envelopes inside the Kodak Farmer's Reducer package. The one marked A contains potassium ferricyanide (a bleach), and the one marked B contains sodium thiosulfate (hypo).

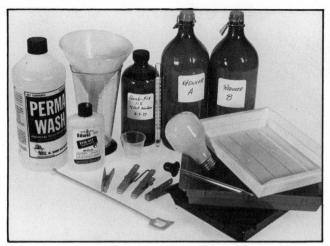

81. Negative reduction calls for a few special pieces of hardware and several items of both hardware and software already in your darkroom. The special hardware includes: a set of three 5×7-inch **trays** (handy for 35mm negative strips of up to 5 frames in length); 4 plastic **clothespins,** 2 of them joined by a wire frame (see Figure 70); and a pair of storage **bottles** of 16 ounces or more capacity. Items already in your darkroom include: **Quick-Fix** working-strength (1:5) fix solution with full hardener; **Perma Wash** hypo eliminator; **Kwik-Wet** wetting agent; a frosted **75-watt bulb**; a **funnel**; an **eyedropper**; a **stirring rod**; a **16-ounce graduate**; and a **1-ounce graduate.**

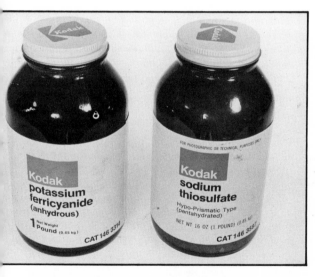

80. Both of these chemicals are very cheaply bought in the 1-pound bottles shown. The convenience-packaged, premeasured Kodak Farmer's Reducer can be used to reduce overexposed negatives, but there isn't enough of either ingredient supplied to prepare the 2-bath **proportional reducer** (Kodak Formula R-4b) that should be used to correct **overdeveloped** negatives. A proportional reducer removes almost equal **proportions** of silver from highlight, middle-tone, and shadow areas on a negative. That means that a greater quantity of silver is removed from highlights than from middle tones and that more silver is removed from middle tones than from shadow areas. The 2-bath reducer formula can improve overdeveloped negatives by **reducing** both **contrast and density.**

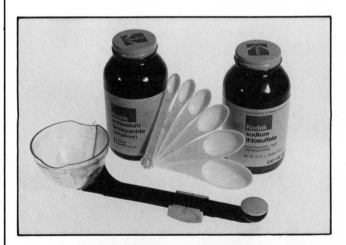

82. If you wish to reduce overdeveloped negatives, or work more economically, you will need a 1-pound jar of Kodak **potassium ferricyanide** (anhydrous), a 1-pound jar of Kodak **sodium thiosulfate** (pentahydrated); a set of kitchen **measuring spoons** (⅛ teaspoon through 1 tablespoon) or a reasonably accurate **scale** that can be read down to about ½ gram.

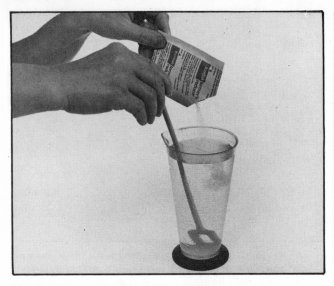

83. To reduce an **overexposed** negative, slowly add the contents of Kodak Farmer's Reducer packet A to 16 ounces (473 ml) of water at 68°F (20°C). Stir until the orange-colored powder is dissolved.

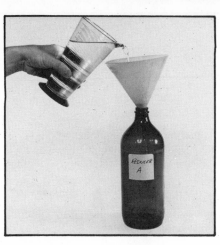

85. Pour the bleach into a glass container labeled "Reducer A" and put the bottle aside. Thoroughly wash the graduate, stirring rod, and funnel.

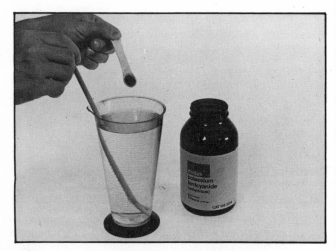

84. Alternatively, measure a level ⅛ teaspoonful of potassium ferricyanide (or use your scale to weigh out 1 gram of the material), add it to 16 ounces (473 ml) of 68°F (20°C) water in the graduate, and stir until the powder is dissolved.

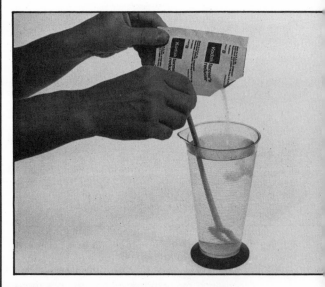

86. Slowly add the contents of packet B (hypo) to 16 ounces (473 ml) of 68°F (20°C) water in the graduate. Stir until the powder is dissolved.

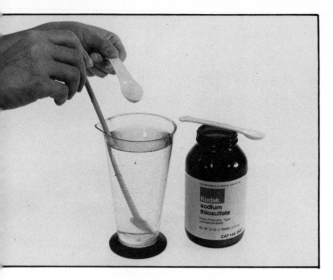

87. Alternatively, measure out 2¼ level teaspoonfuls of sodium thiosulfate (or use your scale to weigh out 14 grams of the material), add it to 16 ounces (473 ml) of 68°F (20°C) water in the graduate, and stir until the white powder is dissolved.

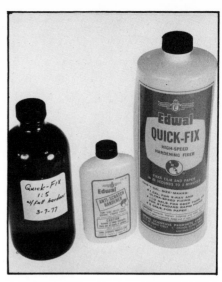

89. You will need some of your premixed, working-strength (1:5) Quick-Fix solution with full hardener (for mixing directions, see **Basic B&W Darkroom**).

88. Pour the fix into a glass container labeled "Reducer B" and put the bottle aside. Thoroughly wash the stirring rod, graduate, and funnel.

90. Negatives which are to undergo reduction must be completely clean and properly fixed and hardened (see **Basic B&W Darkroom**). The entire reduction process is carried out in normal room light.

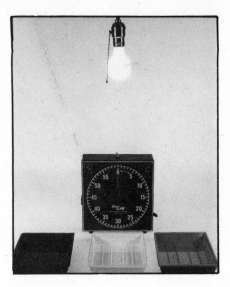

91. It is helpful to set up the working area with 3 trays, side by side, with a clock and a viewing light handy.

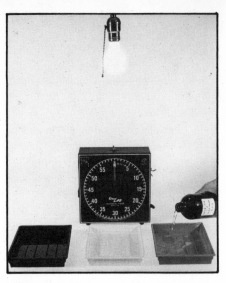

93. Pour 16 ounces (473 ml) of Quick-Fix (1:5, with full hardener) working-strength solution into the tray on the right end of the line. Leave the tray on the left empty.

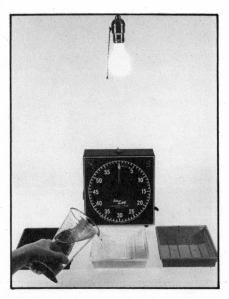

92. Add 16 ounces (473 ml) of water at 68°F (20°C) to the center tray.

94. If the overexposed negatives to be reduced have already been dried, place them in the water, **emulsion side up,** and allow them to soak for 10 minutes.

95. After the 10-minute soaking period has elapsed, add 8 ounces (237 ml) of the contents of bottle A to the graduate.

96. Then immediately add 8 ounces (237 ml) from bottle B to the graduate, to bring its contents to the 16-ounce (473-ml) level. Stir the bleach-fix mixture of the A and B solutions until uniform.

97. Remove the negatives from the center tray and place them, **emulsion side up,** in the lefthand tray.

98. Set 4 minutes on the timer and start it. Pour the contents of the graduate over the negatives.

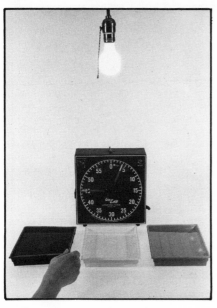

99. Immediately begin to agitate the solution by lifting and lowering one corner of the tray.

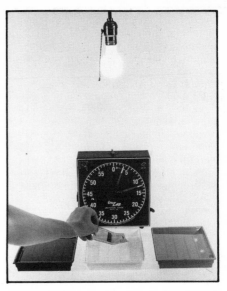

101. Put them in the water in the center tray. Agitate them for a few seconds.

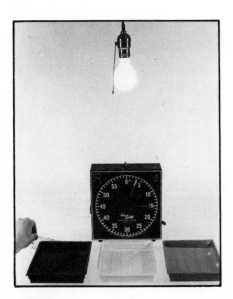

100. After about 45 seconds, remove the negatives, taking care to grip them by the edges only.

102. Examine them to see if the desired degree of reduction has been achieved. If it hasn't, return the negatives, **emulsion side up**, to the lefthand tray and repeat the previous 4 steps.

103. Examine the negatives again to see if they have reached the proper level of reduction. If they haven't, repeat the previous 3 steps again until they have. If after 4 minutes of reduction the negatives are still too dense, discard the bleach-fix solution in the tray, mix a second 16-ounce (473-ml) quantity, and continue with the reduction process. The bleach-fix solution has only a very short useful life.

105. After the wash has been completed, place the negatives in the tray containing the working-strength Quick-Fix solution and agitate for 1 minute and 45 seconds.

104. When observation (and experience) indicates that the desired degree of negative reduction has almost been achieved (the reduction continues for a short while after the negatives are removed from the bleach-fix), put the negatives back in the water tray and wash them in running 68°F (20°C) water for 1 minute. If running water is not available, use four 16-ounce (473-ml) changes of wash water, discarding each after 15 seconds.

106. Then put the negatives back into the water tray and wash them under running 68°F (20°C) water for at least 1 minute. If no running water is available, use four 16-ounce (473-ml) changes of water, discarding each after 15 seconds.

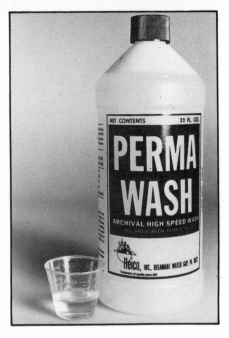

107. While the negatives are washing measure ⅜ ounce (11 ml) of Perma Wash in a 1-ounce graduate.

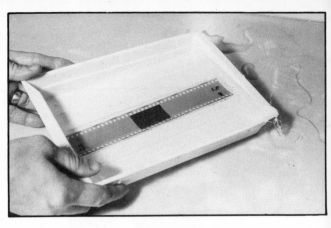

109. When the wash has been completed, carefully pour the wash water out, leaving the negatives in the tray.

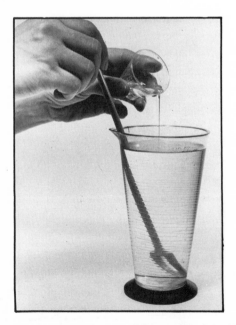

108. Add the ⅜ ounce (11 ml) of Perma Wash to 16 ounces (473 ml) of 68°F (20°C) water in the graduate, and stir until the solution is uniform.

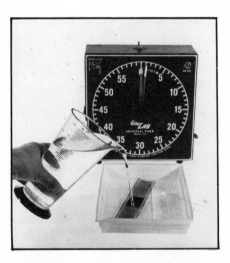

110. Pour the working-strength Perma Wash solution just prepared over the negatives in the tray. Agitate for 1 minute, then carefully empty the tray, leaving the negatives inside.

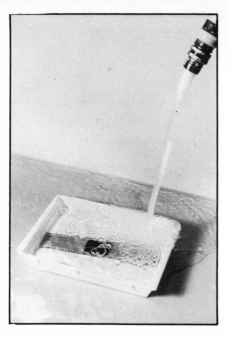

111. Wash the negatives under running 68°F (20°C) water for 5 minutes. If running water is not available, wash the negatives in the tray, using a 16-ounce (473-ml) change of water every 30 seconds for 5 minutes.

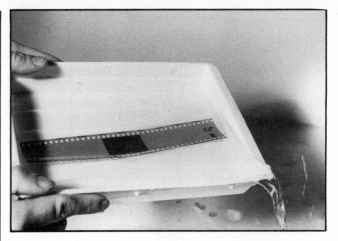

113. When the wash period is over, carefully empty the tray, leaving the negatives inside.

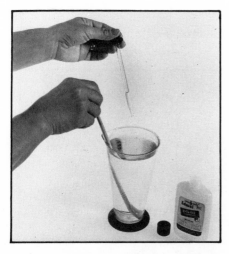

112. While the negatives are washing, clean the graduate and the stirring rod and prepare a working-strength solution of wetting agent by adding 12 drops of Kwik-Wet concentrate to 16 ounces (473 ml) of 68°F (20°C) water and stirring until the solution is uniform.

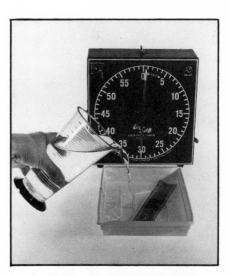

114. Set 30 seconds on the clock, start it, and gently pour the wetting agent over the negatives in the tray.

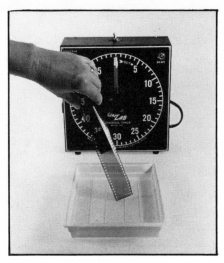

115. After 30 seconds, remove the negatives from the tray and check to make sure that the wetting agent covers the entire surface. If it doesn't, put them back into the wetting agent for a moment and check again. If even sheeting still isn't obtained, wash the negatives for a few minutes longer, wipe them with a clean photo chamois, replace them in the wetting agent for a few moments, and then remove them.

117. The negative at the top is the 3-stops-over-exposed/normally-developed one shown in Figure 76. The one at the bottom is a normally exposed and normally developed negative, and the one in the center was 3 stops overexposed, normally developed, and subsequently reduced in Formula R-4a for 2½ minutes. There is a considerable improvement in density and contrast and a marked absence of fog in the negative that has been reduced, but some chemical stain has been suffered in the process.

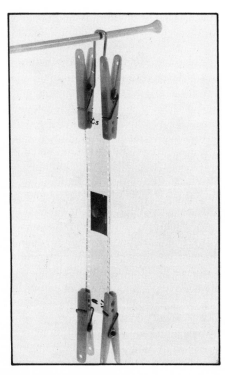

116. Hang the negatives in a dust-free area to dry (see Figures 69–70 for details of the clothespin-hanger arrangement).

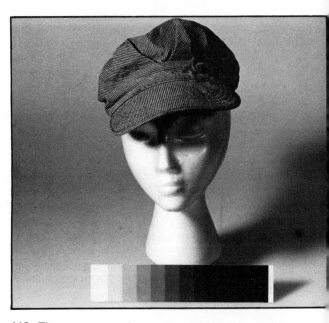

118. The overexposed negative yielded this straight print made on Kodak Polycontrast Rapid RC paper through a No. 2½ Polycontrast filter.

119. This straight print was made from an identically overexposed negative after it had undergone 2½ minutes of reduction. The print, made through a No. 2½ Polycontrast filter, shows more highlight detail and contrast, but it also shows a stain acquired during the reduction process.

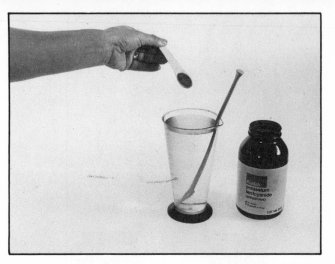

121. However, the R-4b formula does call for a **2-bath** system and different bleach- and fix-solution concentrations. Mix the bleach by adding a level ½ teaspoonful (3.25 grams) of potassium ferricyanide to 17 ounces (500 ml) of water at 68°F (20°C) and stirring until the solution is a uniform light yellow color and all of the crystals have dissolved.

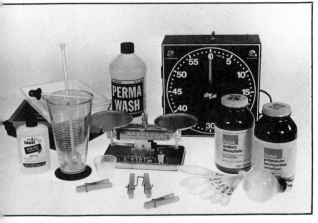

120. Correcting an **overdeveloped** negative with proportional reduction is carried out with much the same methods and essentially the same materials as those used for the cutting reduction (shown in Figures 78–116). However, with Kodak Formula R-4b there is no need for Quick-Fix solution or storage bottles.

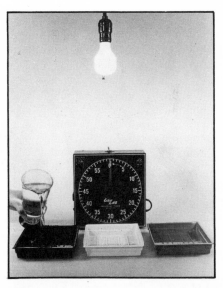

122. The 3-tray setup used in the earlier 1-bath reduction system is retained, but the **bleach alone** is added to the tray on the left end.

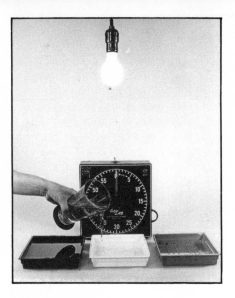

123. Fill the center tray with 68°F (20°C) water.

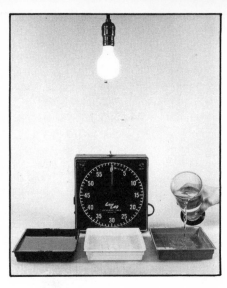

125. Add the fix to the tray on the right end of the line.

124. The fix is made by adding 6 level tablespoons (100 grams) of sodium thiosulfate to 17 ounces (500 ml) of 68°F (20°C) water and stirring until all the crystals are dissolved and the solution is uniform. Crushing the large crystals with the end of the stirring rod speeds this process up.

126. If the negatives have been dried, soak them for 10 minutes in the center water tray. Then follow the steps shown in Figures 97, 99–102, and 104, for no more than 4 minutes.

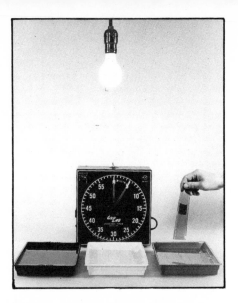

127. When the desired amount of reduction is obtained (or after 4 minutes of bleaching), place the washed negatives in the fix tray and agitate them for 5 minutes. (If reduction is insufficient after fixing, wash the negatives for 1 minute and return them to the bleach tray for up to another 4 minutes. Then wash them for 1 minute and refix them for 5 minutes. This procedure may be repeated, as necessary, until they are sufficiently reduced.) After the final fix step has been completed, the remainder of the processing is carried out as shown in Figures 106–116.

128. The negative at the top is the normally-exposed 50-percent-overdeveloped one shown in Figure 77. The negative at the bottom was normally exposed and developed. The one in the center was also properly exposed and 50 percent overdeveloped, but it was subsequently proportionately reduced in Kodak Formula R-4b. There is considerable improvement in density and contrast, but some chemical stain has been suffered in the process.

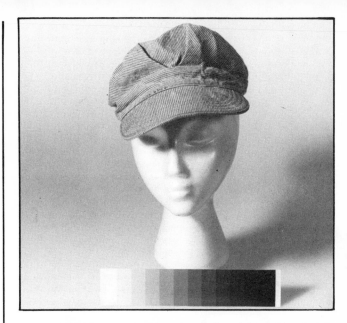

129. The overdeveloped negative yielded this straight print made on Polycontrast Rapid RC paper through a No. 2½ Polycontrast filter.

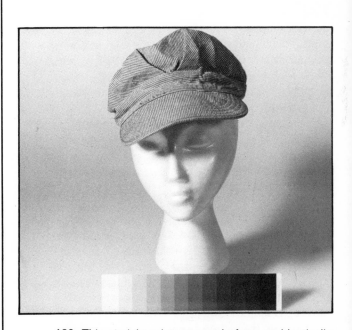

130. This straight print was made from an identically exposed, identically overdeveloped negative that underwent 1½ minutes of proportional reduction. The print, made on Polycontrast Rapid RC paper through a Polycontrast No. 2½ filter, shows more detail and less contrast. As a general rule, always avoid further chemical processing of an improperly exposed or developed negative unless it is completely impossible to reshoot. Negative **intensification** and **reduction** are absolute **last resorts.**

Part II Manipulating Prints

This portion of the book will deal entirely with matters concerning printing paper, such as local stopping, to hold back a portion of the image during its development; hot souping, to intensify a portion of the image during development; local and overall bleaching, to lighten part or all of a print during or after its processing; toning for contrast enhancement, color change, or aesthetic considerations. I will also offer some advice on print finishing—the processes that take place in normal room light, after the darkroom chores are done—such as spotting, to correct image flaws, and both dry and adhesive mounting, to enhance the presentation of your prints.

I'll continue to present data as I have in the first part of the book, in a picture-with-caption style, to **show** rather than tell you how to do things. And for the sake of clarity and simplicity, I will continue to avoid offering several alternative ways to do the same thing if I have found that there is one way that offers advantages over others. In this connection, it is only fair to note that the first two topics I will illustrate—local stopping and hot souping—**are** alternative methods for achieving basic photographic effects. What's more, they are poorer methods than those I've already offered. However, I think my reasons for presenting these apparent contradictions are sound. Although local stopping is an alternative to dodging, and hot souping is an alternative to burning-in (and neither should be used if you can do a proper job of dodging or burning), they are, unfortunately, occasionally very useful because there are times when dodging or burning is either too difficult or too time-consuming. Both local stopping and hot souping are methods that will, when mastered, produce results comparable to dodging and burning-in. They are primarily useful to the experienced printer who is in a rush to meet a deadline and can't afford the time needed to re-expose a print properly. Both methods require you to be able to recognize an improperly exposed image **as it comes up in the developer tray.** Both methods are sufficiently useful that every printer should at least be aware of their existence and reasonably familiar with their practice. Having, I hope, explained away my apparent lapse in resolve concerning photographic methods and procedures, I do want to reassure you that I will continue to limit the data offered here to as few materials as possible. The ones I do mention are those I've personally used and found to offer satisfactory performance. They may not be the ones you eventually decide to use, but the information offered here will, in general, be applicable to a wide range of similar products.

LOCAL STOPPING

131. You may remember this shot from my example of dodging in **Basic B&W Darkroom.** Here, a straight print shows the model's shadowed face as murky and lacking in detail. The **best** way to remedy this situation would be to **dodge** the face carefully, but, as an alternative, **local stopping** can be used to achieve a similar result.

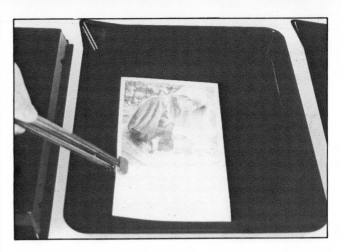

133. When local stopping is used, it is necessary to develop the print by **inspection** rather than by time and temperature. The first step in the process is to put the exposed sheet of paper into the developer tray and agitate until the portion of the image to be held back is just visible under your safelight.

132. Before you undertake local stopping, you should have all of the simple tools you will need prepared and handy. Your local-stopping tool kit will consist of an inverted **tray,** a **cotton swab** that has been dipped into your **stop-bath** tray, and a clean, dry piece of **paper towel** folded into a pad. Put all the items close by the developer tray, where you can get to them quickly, as this process is very time-critical.

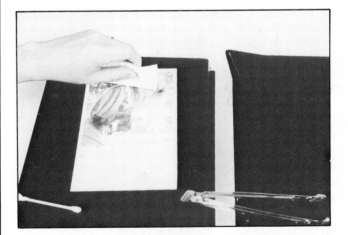

134. Then quickly remove the print from the developer tray, place it, **emulsion side up,** on the inverted tray and use the paper towel to quickly dry the developer off the portion of the print you want to hold back (the model's face in this example). **Do not remove the developer from the rest of the print.**

135. Now immediately apply the stop-bath–soaked cotton swab to the area you want held back. Take care not to slop the stop bath over into areas you want to develop normally. The acid stop bath arrests the developer's action where it is applied, but doesn't affect the development of the remainder of the print, which is still wet with developer solution.

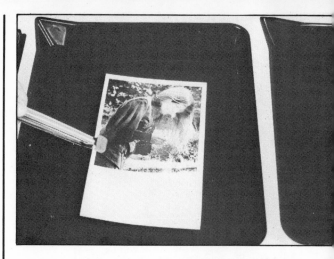

137. Return the print to the developer tray and agitate it for several seconds. This is usually long enough for the area surrounding the portion of the print to which stop was applied to begin to blend with the rest of the picture. This blending has to be seen to be believed, but it actually does occur.

136. Watch the print carefully until you observe that little or no additional development is taking place (the developer remaining on the print will often be exhausted in about 15 to 20 seconds). Then place the print under running 68°F (20°C) water and thoroughly rinse the stop bath and the spent developer from its surface. (If no running water is available, agitate the print in a tray of 68°F [20°C] water to rinse it clean.) After the print has been thoroughly rinsed, hold it by one corner and allow it to drip dry.

138. Next, quickly lift the print from the developer tray, place it on the inverted tray, and use the paper towel to dry the area to be held back.

139. Dip the swab into the stop-bath tray and apply stop to the area to be held back while taking care to keep it off the areas you want to develop normally. The developer solution remaining on the print will continue to work except where the stop has been applied.

141. Return the print to the developer tray. Agitate it until you are satisfied that the area surrounding the held-back portion of the print has blended sufficiently with the remaining area of the print and until the correct overall print density has been reached. Then remove the print from the developer and continue to process it normally (see **Basic B&W Darkroom**).

140. When you see that no further development is taking place, put the print under a stream of running 68°F (20°C) water (or into a tray of clean water) and thoroughly rinse the expended developer and the stop off the print surface. Then drain the print.

142. Local stopping usually does not provide results technically comparable with those obtained by very careful dodging, but it is often a handy and practical technique to use. Both this and Figure 131 were made with identical printing exposures, and local stopping was the only technique that was used to lighten the model's face.

HOT SOUPING

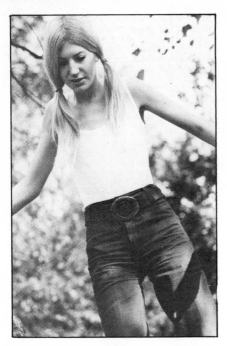

143. This print is identical to the one (in **Basic B&W Darkroom**) I used to illustrate an image that was in need of burning-in. The large area of the very white tank top the model is wearing is distracting and needs to be darkened. **Hot souping** can also be used to this end quite effectively.

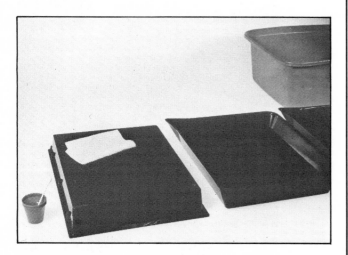

144. The hardware needed for hot souping includes an inverted **tray**, a clean, padded **paper towel**, a **cotton swab**, and a small **container**. Before you begin hot souping, the inverted tray should be placed next to the developer tray. The small container should be partially filled with the **stock solution** of the developer you are going to use in the developer tray in working-strength dilution, and placed close to the inverted tray. The cotton swab should be placed in the container.

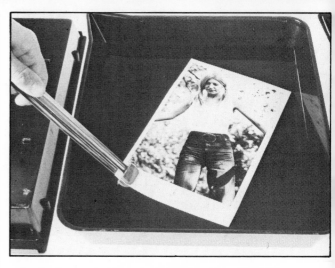

145. When hot souping is done, the print must be developed by a combination of **inspection** and **time/temperature**. The first step is to place the print in the developer tray and agitate, as you do when processing normally, for about 1 minute. If after this much development time you do not see sufficient tone in some area of the print (under normal safelight illumination), you will have to use hot soup (stock-solution-strength developer) to **force** development in that area.

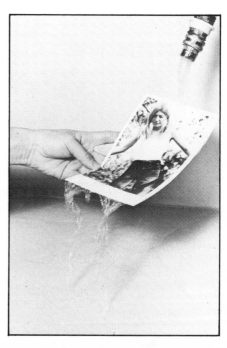

146. Remove the print from the developer tray and place it under 68°F (20°C) running water (or, if no running water is available, in a tray of clean water) to rinse the developer thoroughly from the emulsion surface of the print. Allow the rinse water to drip off the print.

147. Place the print, **emulsion side up,** on the inverted tray. Use the padded paper towel to dry the surface of the print.

149. Observe the print closely to determine when the desired density is reached, or, more likely, when the developer you have swabbed on ceases to produce any further effect. If the first swabbing fails to produce the desired results, use the cotton swab carefully to add more hot soup to the area being intensified.

148. Use the cotton swab to apply the concentrated developer to the area of the print to which you wish to add density. Do this carefully to avoid getting the hot soup on areas you do not wish to intensify.

150. Continue this procedure for as long as necessary until the area you want toned is sufficiently darkened. If you have thoroughly rinsed the developer from the print's emulsion (see Figure 146), there will be little development of any area of the print except that which is being swabbed with hot soup.

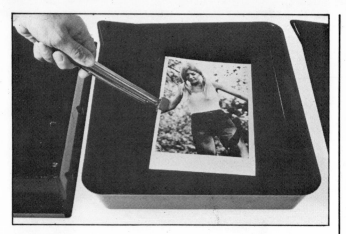

151. Once the area being darkened has reached the desired density, put the print back into the developer tray and agitate it for about 30 seconds, to blend all areas of the print and to complete the development of areas not being hot souped. Continue to process the print as you normally would any other.

BLEACHING

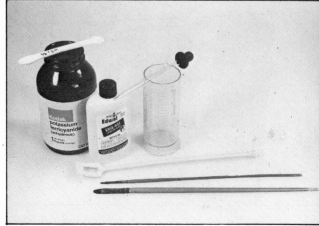

153. The only equipment not already in your darkroom that is needed for **bleaching** prints is some good-quality artist's **sable brushes** and a **4-ounce graduate.** The **potassium ferricyanide, ⅛-teaspoon measure, Kwik-Wet** wetting agent, **eyedropper,** and **stirring rod** are all items we've used before.

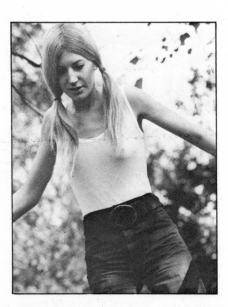

152. Hot souping most often does **not** provide results technically comparable with those that can be obtained with very careful **burning-in**, but it is often a handy and practical darkroom technique, one which can save otherwise unacceptable prints. This hot-souped print is a considerable improvement over Figure 143.

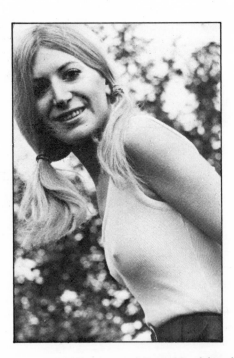

154. This shot could be improved by a bit of **local** bleaching. The model's eyes are in shadow and lack detail. Her teeth appear to be dark and unattractive. Local bleaching can easily fix these problems in a few moments, avoiding the need to reprint with intricate dodging.

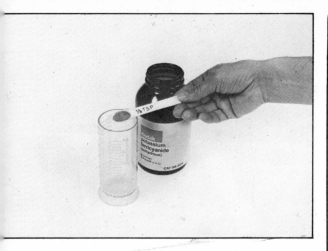

155. To prepare a local bleaching solution, add a level ⅛-teaspoon measure (1 gram) of potassium ferricyanide to the 4-ounce graduate.

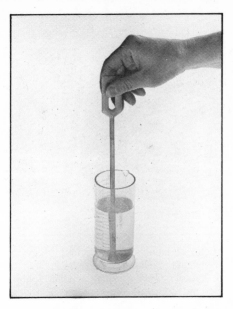

157. Finally, add 4 ounces (118 ml) of water and stir until the solution is uniform and of a weak-tea color. This concentration of ferricyanide solution provides semiproportional reduction when used with the working-strength (1:7) solution of Edwal's Quick-Fix I've recommended (see **Basic B&W Darkroom**) for normal use in fixing prints.

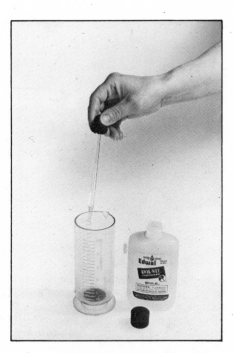

156. Then add 3 drops of Kwik-Wet. (This step is optional, and the wetting agent should be reduced or eliminated entirely if you find that areas adjacent to those being bleached are being affected.)

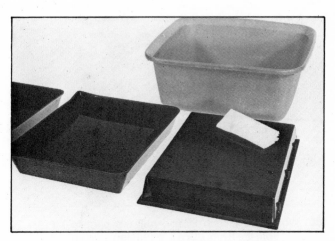

158. An inverted tray and a piece of paper towel folded into a pad can come in handy for local bleaching. This time they should be placed at the hypo-tray end of the tray line, where they will be used in normal room light.

159. A print can be bleached as soon as it has been fixed. With Polycontrast Rapid RC and fresh Quick-Fix at a 1:7 dilution, it is safe to turn on white lights 30 seconds after the print has entered the fix tray and been continually agitated. (I often cut this period in half when I'm in a hurry.)

161. Dip a No. 1 brush into the **ferricyanide-solution** graduate. Work the excess solution off by drawing the brush over the rim of the graduate before applying the tip of the brush to the areas to be lightened. Take care not to get the bleaching solution on areas you want to keep at a constant print density. Working on this print, I painted the bleach into the white portions of the right eye, the whole left eye, and across the teeth.

160. When you bleach locally, pull the print to be bleached from the hypo, place it, **emulsion side up**, on an inverted tray, under a good bright source of white light, and carefully dry only the portions of the print that are to be bleached (the eyes and teeth in this illustration).

162. Watch the print to see that a **gradual** density reduction is taking place where you have applied the ferricyanide solution. If the bleaching action is very fast with the printing material you are using, discard half the bleach solution and add 2 more ounces (59 ml) of water to the remaining half. Bleaching should be done **very** slowly and in several stages. After you note that no further reduction is taking place, hold the print under running 68°F (20°C) water (or agitate in a tray of fresh water) to rinse the bleach solution off the emulsion. Don't be alarmed by yellow stains you may see in highlight areas after this rinsing has been completed. They will disappear in the next bleaching step.

163. Drain the rinse water from the print and return it to the fix tray. If necessary, rub the soft rubber tip of the print tongs over the yellow-stained areas until all signs of yellow stain disappear.

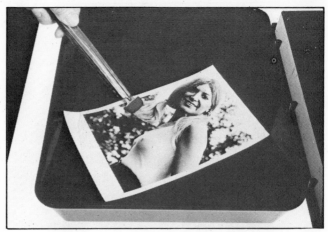

165. Once the desired level of local bleaching has been obtained, rinse the bleach solution from the print surface. Then return the print to the fix tray. Remove any yellow stains by rubbing gently with the soft tip of the print tongs. Then continue to agitate the print in the fix for another 3 minutes. After this has been done, the print may be washed and dried as any normally processed print (see **Basic B&W Darkroom**). Note that some slight continued density reduction takes place during this final fixing. After a few trial prints you will learn how much to allow for this continued lightening, but the first few times you try local bleaching it may fool you.

164. Repeat the processes shown in Figures 160–163 until the desired level of local bleaching has been reached. This process should require several such sequences before it is completed. Don't try to rush things by increasing the concentration of the ferricyanide solution, as doing so will both modify its reducing characteristics (causing it to provide a cutting action rather than a more proportional reduction) and lead to an uncontrollable situation. Going very slowly is the **only** way to achieve accurate control over this somewhat tricky process.

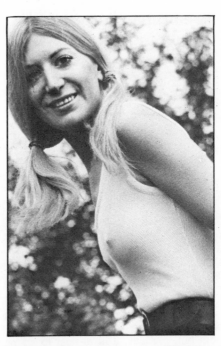

166. Don't overdo local bleaching. This print shows the results of bleaching both the eyes and the teeth to a reasonable level. The print has been improved by the effort.

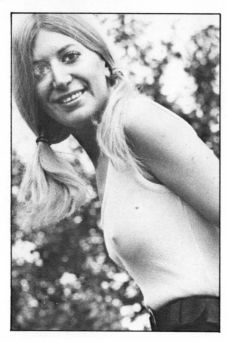

167. This print is a prime example of overdoing local bleaching. The results are nothing short of grotesque, and the print has been ruined.

Large-Area Bleaching and Silhouetting

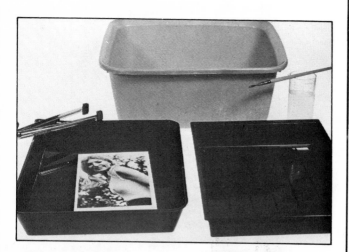

168. It is very often desirable to **silhouette** a photographic image. This can be done several ways outside the darkroom but, perhaps, it is easiest to do right alongside the fix tray. Let's start with the same shot of a pretty woman we used for local bleaching, but this time we'll remove all of the image detail above the model in the righthand corner of the photograph.

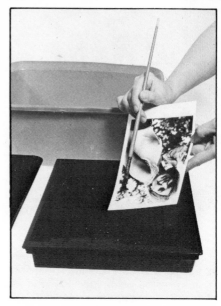

169. After the image has been fixed, remove it from the hypo tray and hold it so that any bleach solution applied to it will run down **away** from the image area you wish to keep intact. Use the same bleach solution prepared for local bleaching (Figures 155–157), except that the Kwik-Wet may be reduced or entirely eliminated if you notice that areas adjacent to those being bleached are being affected. Use a No. 7 brush to apply liberal amounts of bleaching solution to the area of the print to be silhouetted. Be very careful to avoid brushing bleach onto any area you want to keep intact. Here, too, yellow staining of bleached areas will occur, but these stains will be removed during the subsequent steps.

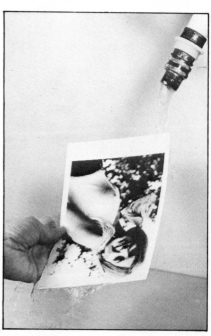

170. When the bleaching action seems to slow or stop, rinse the bleach solution off the surface of the print under a stream of 68°F (20°C) running water (or agitate the print in a tray of clean water). Allow the print to drip dry.

171. Return the print to the hypo tray and gently rub the soft rubber tip of the print tongs over the yellow-stained area of the print until all signs of the stain are removed.

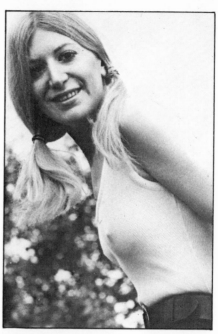

173. This print shows the results of the bleach (containing a wetting agent) leaching into an area along the top of the model's arm. This was predictable because the density of the adjacent image being removed was far greater than the density of the area to be preserved. Even with a proportional reducer and a good deal of care the amount of reduction needed was enough to damage the adjacent image area. I stopped the reduction at a level that left a faint outline of the model's arm, to illustrate this point better. (It may be difficult to see this faint line in reproduction here.) Silhouetting with ferricyanide is primarily useful for photographs intended for magazine or book reproduction. I do not recommend this technique for prints that are to be exhibited.

Overall Bleaching for Contrast

172. Repeat the steps shown in Figures 169–171 until you have removed all the silver image except what you wish to retain. This technique is particularly useful when a plain, white, seamless background is unavailable, but a silhouetted image is required.

0	1	2	3	4	5
0000	0043	0086	0128	0170	0212
0414	0453	0492	0531	0569	0607
0792	0828	0864	0899	0934	0969
1139	1173	1206	1239	1271	1303
1461	1492	1	1553	1584	1614
1761	1790	18	847	1875	1903
2041	2068	2095	2	2148	2175
2304	2330	2355	2	2405	2430
2553	2577	2601	26	8	2672
2788	2810	2833	285		2900
010	3032	3054	3075		118
22	3243	3263	3284	3	
24	3444	3464	3483	35	
17	3636	3655	3674	369	

174. This simple photographic illustration suffers from a lack of **contrast**. What is really needed are black numbers against a white page. Tonal gradation is totally out of place here. The print could be remade on a harder grade of paper or it can be saved by **overall bleaching.**

175. To prepare an overall-bleaching solution, mix ¼ teaspoon (2 grams) of **potassium ferricyanide** in 1 quart (946 ml) of water until the solution is uniform and of a very light yellow color.

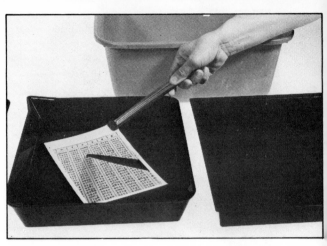

177. Fix the print to undergo overall bleaching; then, without draining the print . . .

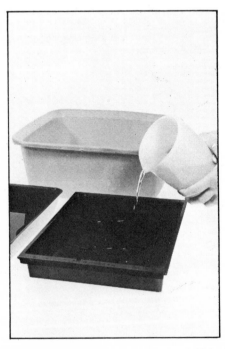

176. Place a tray alongside the hypo tray, and fill it with the overall-bleaching solution.

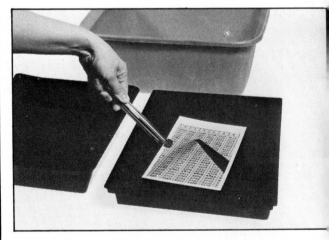

178. . . . use the fix tongs to slide it quickly and completely beneath the surface of the bleaching solution. Be sure to do this as fast as you can; otherwise, uneven bleaching may occur. Agitate the bleach over the print for a few seconds.

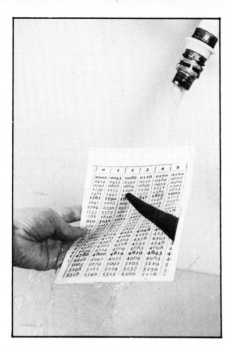

179. Remove the print from the bleach tray and put it under a stream of 68°F (20°C) water (or agitate it in a tray of clean water) to rinse the bleach from all surfaces of the print. You should notice an increase in print contrast at this point in the process.

181. Again, without draining the print, use the fix tongs to remove it from the hypo tray and slide it quickly and completely under the surface of the bleach solution. Agitate the print for several seconds. Repeat the steps shown in Figures 178–180 as often as needed until the desired degree of contrast increase is obtained. However, after about 5 minutes the bleach solution should be discarded and replaced with a fresh supply.

180. Return the print to the hypo tray and agitate it for several seconds or until all signs of yellow stain disappear.

0	1	2	3	4	5
0000	0043	0086	0128	0170	0212
0414	0453	0492	0531	0569	0607
0792	0828	0864	0899	0934	0969
1139	1173	1206	1239	1271	1303
1461	1492	1	1553	1584	1614
1761	1790	18	847	1875	1903
2041	2068	2095		2148	2175
2304	2330	2355		2405	2430
2553	2577	2601	2	8	2672
788	2810	2833	285		2900
010	3032	3054	3075		118
222	3243	3263	3284	3	
424	3444	3464	3483	35	
17	3636	3655	3674	3692	
02	3820	3838	3856	3874	
79	3997	4014	4031	4048	40
50	4166	4183	4200	4216	423
4	4330	4346	4362	4378	4393
2	4487	4502	4518	4533	4548
4	4639	4654	4669	4683	4698
1	4786	4800	4814	4829	4843
	4928	4942	4955	4969	4983
	5065	5079	5092	5105	5119
	5198	5211	5224	5237	5250
	5328				

182. Compare this print with the one shown in Figure 174. Both were identically exposed and processed, but this print underwent several additional overall bleaching baths and was considerably improved in the process.

TONING

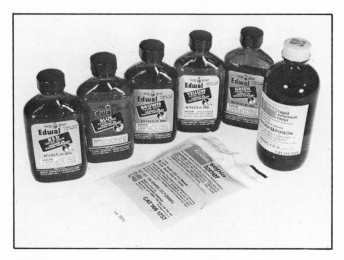

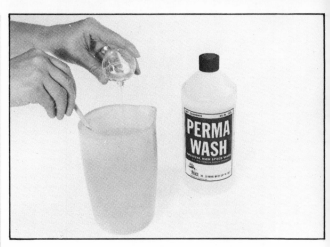

183. Each of the toners shown above, **Kodak's Rapid Selenium** and **Sepia Toners** and **Edwal's Color Toners,** will produce different results with different types of paper. Some toners are incompatible with some papers. Some toners will work satisfactorily with some grades of a specific type of paper and less so with others. Some toners will work satisfactorily with plastic-coated papers and others won't. The only way you can be sure if any given toner will work on the particular print you have in hand is to try the combination first with a few scrap prints. Before toning **any** print, be absolutely sure that the print has been washed **completely** free of hypo. If it hasn't, uneven toning or staining may result. Running water should be available for the washing steps required by all pretoning and toning processes. It is also often helpful to omit the usual hardener from the fix used for prints to be toned.

185. While the print is being washed, mix a working-strength (1:42) solution of Perma Wash by adding ¾ ounce (23 ml) of the concentrated solution to 32 ounces (1 liter) of 68°F (20°C) water and stirring until the solution is uniform.

184. If you have any doubt about how well a print to be toned has been washed, or if the print has just been fixed, it is prudent to wash the print for 5 minutes in 68°F (20°C) running water. (If you are sure the print is free of hypo and has already been dried, it need only be soaked in a tray of 68°F [20°C] water for 10 minutes prior to toning.)

186. Pour the working-strength Perma Wash solution into a clean tray. Remove the print from the wash tray. Drain it. Put it into the Perma Wash tray. Allow it to soak in Perma Wash for 5 minutes.

187. Remove the print from the Perma Wash tray and drain it. Put it back into the wash tray for an additional 5 minutes. Now drain the print, and it will be ready for toning.

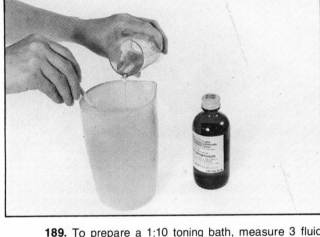

189. To prepare a 1:10 toning bath, measure 3 fluid ounces (89 ml) of Rapid Selenium Toner in a small graduate. Then add the toner to 30 ounces (888 ml) of 68°F (20°C) water and stir until the solution is uniform. This working-strength solution can be stored indefinitely in a brown-glass container and will partially tone about a hundred 8 × 10-inch prints.

Partial Selenium Toning for Contrast and Clarity

188. Kodak's Rapid Selenium Toner is perhaps best used on papers with which it is often thought to be incompatible: those which produce a cold-toned image when normally processed. Although Rapid Selenium Toner can be used at a 1:3 dilution to produce an attractive reddish-brown overall color in the silver image of many warm-toned papers, its unique property is that, used at dilutions greater than 1:9, it can produce an almost indefinable change for the better in the images on cold-toned papers—images that seem to have blacker blacks, increased contrast, and greater clarity and depth than they had before they were toned.

190. Partial selenium toning is best carried out in bright white light. Pour the working-strength toning solution into a suitable tray and then put the wet print into the tray. Be sure the print is completely covered with the toning solution. Gently agitate the print in the toning solution, and observe it carefully. The changes that occur are very subtle and hard to perceive, but the rate of change is slow enough so that you needn't worry about overdoing things. Do not wait until you see the color of the silver image begin to change. The print should be pulled from the toning bath **before** a pronounced color shift occurs. This may be a matter of seconds or of minutes, depending on the paper you are using. With Polycontrast Rapid RC 15 seconds to 1 minute should be adequate.

191. After the partial selenium toning has been completed you should wash the print the same way you did to clear it of hypo (see Figures 184–187). Discard the Perma Wash after using it to clear selenium-toned prints. Some very slight additional toning will continue until washing has been completed. With time you will learn to make allowances for it where necessary. Dry the print as you normally would.

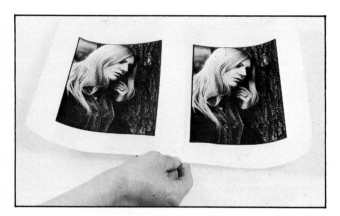

192. When you begin to experiment with Rapid Selenium Toner, it will help to start with two identical prints. Check the print being toned against the untoned print to determine when you have achieved the desired effect and thus when you should pull the toned print from the toning tray. There is no way that this can be illustrated here, as the differences after toning are far too subtle to be reproduced with black printing ink.

Sepia Toning for an "Antique" Effect

193. Of all the available toners, the sepia toner, which produces pleasant brown tones, is the most universally applicable. While the color and effect it produces will vary with different types and grades of paper, it will work with most printing materials. Unfortunately, this toner is the most unpleasant to use. It **must** be used with good ventilation because the hydrogen sulfide gas given off when it is mixed and used has the odor of rotten eggs and is **poisonous.** The maximum capacity of this 1-quart package is forty 8 × 10-inch prints.

194. To prepare the toner, open the outer plastic package, remove the 2 small packets within it, cut the corner off the packet marked "Part A," and add its contents to 1 quart (946 ml) of 68°F (20°C) water. Stir until the powder is completely dissolved. Pour this bleach solution into a plastic, rubber, or glass tray. **Do not use enameled metal trays for this process**.

195. In a **well-ventilated** area, slowly add the contents of the packet labeled "Part B" to 1 quart (946 ml) of 68°F (20°C) water. Stir until the powder is dissolved. Pour this redeveloper solution into a second nonmetal tray.

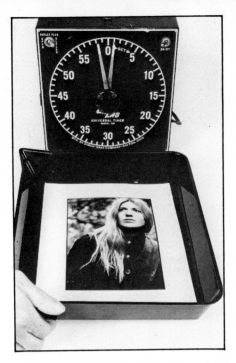

197. Set 1 minute on your **timer.** Start the timer. Put the print into the bleach bath.

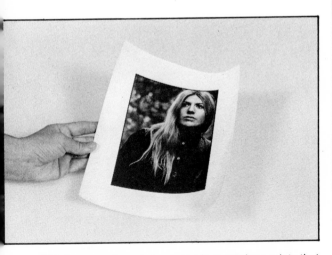

196. In general, sepia toner tends to produce prints that are less dense after toning than they were before. It will be a good idea, therefore, to **overdevelop** prints you intend to tone, by about 15 to 20 percent. Such an overdeveloped print will appear slightly too dark prior to toning. Wash the print as shown in Figures 184–187 before you begin the toning process.

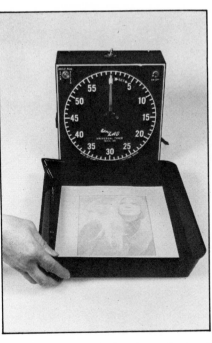

198. After about 1 minute of constant agitation, the image on many types of paper should either disappear or turn light yellow. If it doesn't, simply keep on agitating; it will eventually. (The darkest portion of this particular print on Polycontrast Rapid RC took over 7 minutes to turn yellow.)

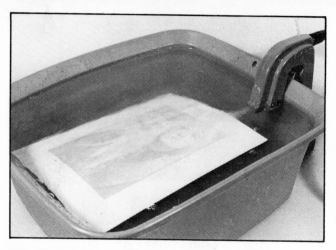

199. Wash the bleached print thoroughly in running 68°–70°F (20°–21°C) water for 2 minutes. Then drain the print.

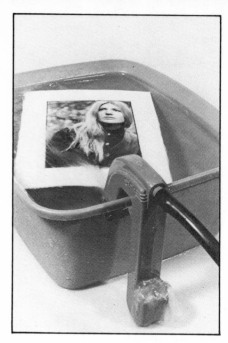

201. Wash the toned print for at least 30 seconds.

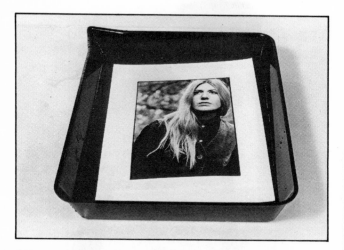

200. Put the print into the redeveloper tray and agitate it until no further change occurs. **Avoid breathing** the sickening stench given off by this redevelopment process, even if it means holding your breath for the 30 seconds or so required.

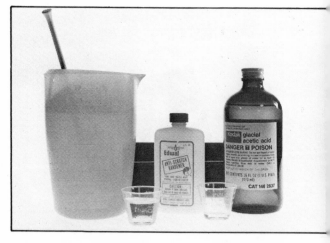

202. Prepare a hardening bath by adding 1 ounce (30 ml) of **Edwal's Anti-Scratch Hardener** to 31 ounces (917 ml) of 68°F (20°C) water. Stir until the solution is completely uniform. Then add ⅛ ounce (4 ml) of **glacial acetic acid** and mix until the solution is uniform. (A hardening solution can also be prepared from **Kodak Liquid Hardener** by adding 1 part of hardener to 13 parts of water.) Pour the hardening solution into a tray.

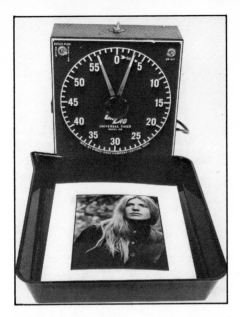

203. Remove the toned print from the wash tray and drain it. Place the print in the hardening solution tray, and allow it to soak there for 3 minutes. Then drain the print.

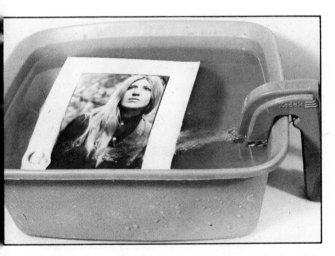

204. Return the print to the wash tray and allow it to wash in running 68°–70°F (20°–21°C) water for 30 minutes. Then dry the print as you normally would.

Toning to Add Colors to the Print

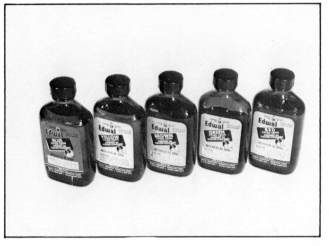

205. Edwal offers a wide variety of color toners: red, green, blue, yellow, and brown. They are all quite easy to use. Like all other toners, these will also produce widely different effects on different types of paper and on different grades of the same type of paper. They can be used to tone all of the silver image on a print by immersing the print in a toner bath, or they can be used selectively to color any portion of a silver image by applying the toners with a swab or brush. Prints may be toned first in one toner, then in another for intermediate color effects. As with all other toners, experiment with scrap prints before attempting to tone a finished print. (See Figures 184–187 for pretoning washing requirements.)

206. Every 4-ounce bottle of Edwal's Color Toner is supplied with a small plastic cup of orange-colored crystalline material. The cup is in the mouth of the bottle, under the cap.

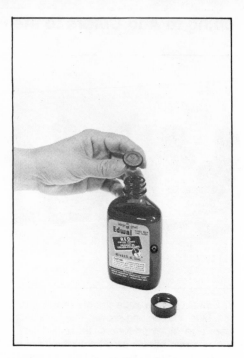

207. To prepare any of the toners for use, the crystalline material must be poured into the bottle and stirred or shaken until it is completely dissolved. The shelf life of the unmixed toner materials is several years; however, once mixed, their shelf life diminishes to several weeks, if the bottle is kept tightly sealed.

209. Prints to be toned in Edwal's Color Toner should be free of any fog or unwanted silver in highlight or border areas, as silver grains in these areas will pick up the toner.

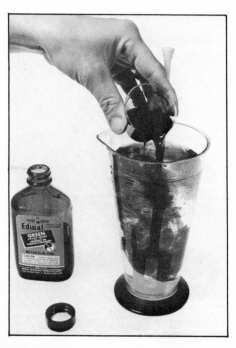

208. To prepare a working-strength solution of any of the Edwal Toner colors add 1 ounce (30 ml) of the premixed toner concentrate to 15 ounces (444 ml) of water. Stir until the solution is uniform. Pour the working-strength toner solution into a **nonmetallic** tray. Working-strength Edwal Toners have about a 1-day shelf life. The toner's working capacity is a function of the depth of color desired in the toned print.

210. Place the wet print under the toner in the tray and agitate occasionally. Note that the opacity of this green toner is enough to make it difficult to see image details—and impossible to follow the progress of the image's color change—through it.

211. Using 1 pint (473 ml) rather than 1 quart (946 ml) of working-strength solution will allow you to tilt an 8 × 10-inch tray far enough to inspect the progress of the toning without spilling any of the toner. Look for the maximum effect in the **thinnest** image areas; solid blacks (the densest areas) will remain unaffected for the greatest length of time.

213. It took over 10 minutes to tone this print, on Polycontrast Rapid RC, to a satisfactory level in Edwal's green toner at 80°F (27°C). The longer the print is toned, the stronger the color of the image will become.

212. If the toning is proceeding at too slow a rate, you can speed it up by increasing the toner's working-strength concentration or by raising the temperature of the toning bath. You can heat the bath quickly by putting the toning tray into a larger tray partially filled with hot water. The toning bath can be brought to 110°F (43°C), if required.

214. Wash toned prints for at least 5 minutes in 60°–70°F (16°–21°C) running water. Use 70°–80°F (21°–26°C) water if most of the toner is to be removed from the highlight and border areas. Getting all the color out of these areas may prove to be quite difficult or impossible. The colors will brighten considerably during washing, and this effect, learned with experience, must be taken into account in determining when to remove the print from the toning bath.

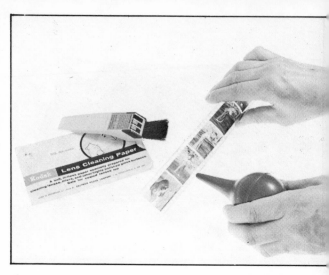

215. Perhaps the most interesting way to use Edwal's Color Toners is to apply the full- or part-strength concentrates directly to small areas with a cotton swab. Here the face is being toned with red toner, which will be followed with yellow toner to produce a warm tan color. The background foliage has similarly been toned green, the model's hair yellow, the portions of her clothing brown. This sort of tinted black-and-white photograph is the simplest and most easily illustrated application of this technique. However, the best application is perhaps for more abstract purposes—which are impossible to show here in black ink on white paper.

PRINT FINISHING AND SPOTTING

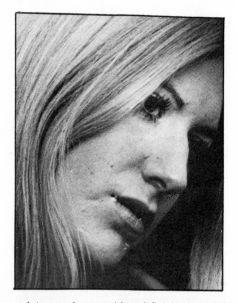

216. Few prints can be considered finished until they have been **spotted.** Spotting consists of filling in the tiny white areas on the print that appear when dirt or dust on the negative projects shadows onto the printing paper. This tightly cropped, highly magnified portrait has several of these white spots around the mouth and chin.

217. The best remedy with a print that needs a great deal of spotting, such as the one shown in Figure 216, is to remove the negative from the enlarger carrier, clean it thoroughly—with a sable brush, the air blast from an infant's ear syringe, or gentle and very careful wiping with a piece of wadded lens tissue—then reinsert it in the enlarger, and make another print.

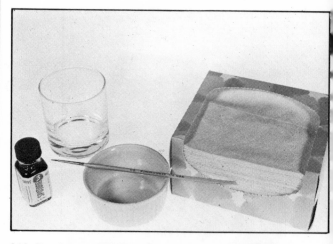

218. But there are times when you have no choice but to fill in the missing image detail yourself. Frequently, the white spots on a print are so small, and so few in number, that reprinting is not really called for. That is when spotting materials are needed. For prints made on Polycontrast Rapid RC, a single bottle of **Spotone No. 3,** a high-quality sable No. 00 **artist's brush,** a white porcelain or plastic **dish,** a small **drinking glass,** and some **facial tissues** are all that you need to do the job.

219. Spotone dyes are available in a number of shades. The most common are No. 0 (olive black), No. 1 (blue black), and No. 3 (neutral black base). Others are No. 2 (selenium brown), No. B (brown), and No. S (sepia). These can be mixed together to match the particular image tones of most paper-and-developer combinations or of several popular toners.

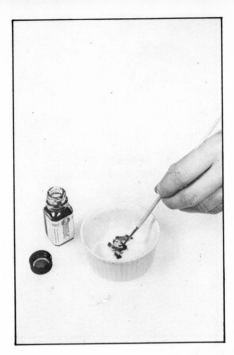

221. Use the brush to spread the dye over the surface of the dish, leaving a drop or two undisturbed in the center.

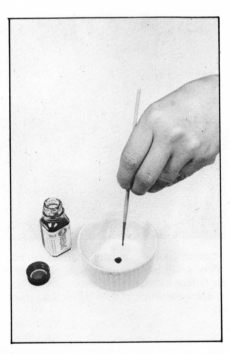

220. There are as many ways to spot prints as there are printers. The method I've found best begins by dipping the brush into the bottle of dye and transferring several drops of dye to the surface of the white dish.

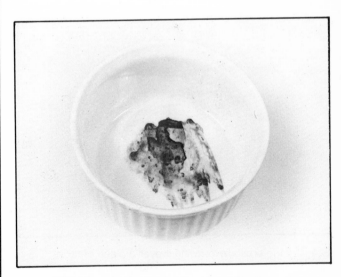

222. Allow the dye to dry for a few minutes.

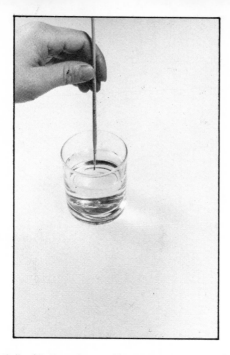

223. Partially fill the glass with water. Immerse the brush in it and swirl it around several times to remove all the dye from the brush.

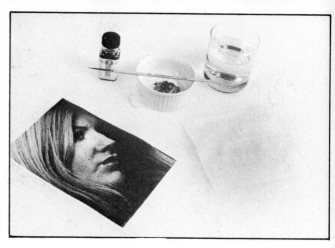

225. Place the print to be spotted in a clean, brightly lit area, with all of the items needed close at hand.

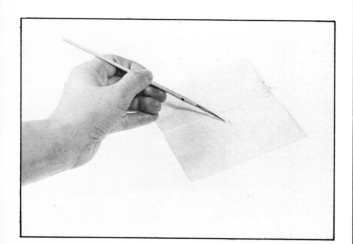

224. Dry the brush by drawing it over a piece of facial tissue while rotating the brush handle between your thumb and forefinger.

226. Viewed close up, the gray image areas are composed of many small black silver grains. Because of this granular image structure, it is necessary to apply the spotting dye as a series of dots rather than paint a solid section.

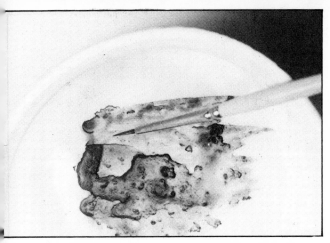

227. Find the **lightest** (least dense) area of the print to be spotted. In this case it's the long white area at the bottom of the model's jaw. Next, find an area of dye on the white dish that you think is of a slightly **lighter** shade of gray. Lightly moisten the clean brush tip on the tip of your tongue, then work the saliva-moistened brush over the area of dye you have selected, to transfer it from the plate to the brush. As you do this, twirl the brush on the plate to point it. (The reason I advise using saliva to moisten the brush is that it enables the brush to be brought to—and hold—a very fine point; it works better than water or water with a wetting agent added. If you object to saliva, I suggest that you substitute a mixture of 1 drop of Edwal's Kwik-Wet or Kodak's Photo-Flo 200, in 1 ounce of water.)

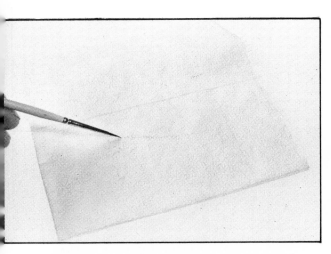

228. Draw the brush lightly over a piece of facial tissue to double check that the line of dye it will deposit is lower in density than that of the area to which it is to be applied. Be sure to note if the line drawn is of uniform density. If it isn't, wash the brush out and repeat the operations explained in Figure 227.

229. When you are spotting a long white area such as this one, first apply several dots of dye along its length, to break up the empty area into segments. Start at one end and apply the dye with an up-and-down motion that brings only the tip of the brush into contact with the print. If the first spot of dye appears darker than its surroundings, immediately clean the brush in water and pass the clean wet brush over the too-dark spot to remove or lighten it. Then blot the area with facial tissue and repeat the steps shown in Figures 227–228.

230. Continue to apply dots of dye along the length of the white area until it is broken into several segments. Transfer dye from the dish surface as required. The dye dots applied should be lighter than their surroundings. Once the area has been entirely segmented, pick one segment and add more dye dots within it to fill in its white area.

231. If the segment filled in is lighter than its surroundings, apply additional dots of dye over those first laid down until the segment blends with its surroundings. The density of the dots of dye is cumulative, so that as one dot is placed on top of another, the area covered by the dye darkens.

233. The process used for filling in small, irregular-shaped spots is identical to the one used for filling the segments of a long, thin line. Begin in the center and cautiously deposit dots outward toward the edges of the spot. Be very careful not to get **any** dye beyond the borders of the spot or you will leave a dark ring around the spot, which will be even uglier than the original white spot was.

232. Continue this filling-in process for each of the segments along the original white line until the entire area is filled and blends into its surroundings imperceptibly. This is much easier said than done. Practice spotting on several scrap prints before ever attempting it on a finished print.

234. Once all of the lighter spots have been filled, proceed to the next darker ones and fill them with dye dots as you did the others.

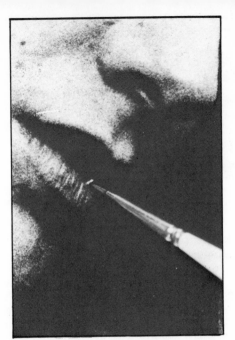

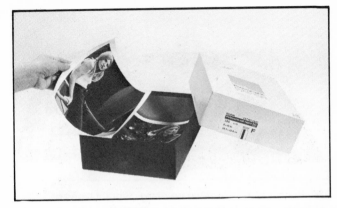

237. Once you have completed a print, you have to decide what you want to do with it. If it is to be stored, no further work is needed. It can be placed in an empty box and kept in an area where it will not be subjected to extremes of temperature or humidity or to air heavily contaminated with pollutants.

235. The hardest spots to fill are those in areas that appear to be solid black. Use the same general procedures and carefully build up the density of the dots applied by overlapping them. Don't ever try to apply all the dye density needed with a single dot.

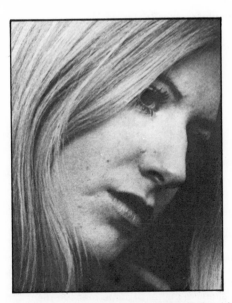

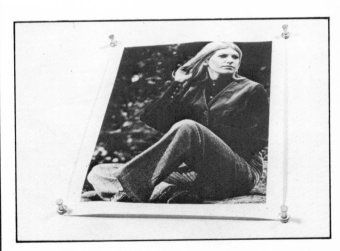

236. After you finish spotting a print, it should be all but impossible to see where the spotting has been done. Properly applied Spotone dye sinks into the emulsion and leaves few if any traces. Don't expect perfection until you have gained a good deal of experience with spotting.

238. If the print is to be displayed, it is advisable to attach it firmly to a flat surface, to prevent print curl or warping from detracting from its appearance as it does here.

239. Prints can be **mounted** on many different types of materials with a large variety of adhesives; however, the most common and practical methods involve the use of **matte-board mounts** and heat- or pressure-sensitive **dry-mounting tissue.**

241. Pressure-sensitive dry-mounting tissue can be used with no machinery other than a simple plastic squeegee, which is normally supplied with the tissue, and some muscle power. This method provides a reasonably good bond between the print and the mounting board. It also offers the distinct advantage that you can easily remove and reposition the print if you make a mistake during mounting, or even later.

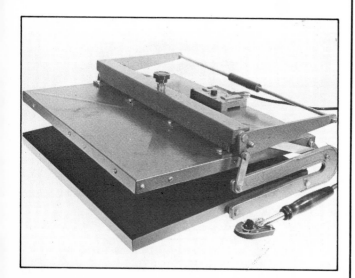

240. The use of **heat-sensitive dry-mounting tissue** calls for a heated **dry-mounting press** and a **tacking iron.** This Technal press will handle mounting boards of up to 18 × 20 inches in size in a single pass. It is an expensive device, but one which is often available to amateurs through camera clubs, schools, or libraries. Such machines provide the **best** means of flattening prints and attaching them to mounting boards.

242. Before the print is mounted, determine its final position on the board accurately. If the print is to be mounted on the board with **symmetrical borders,** positioning is simply a matter of some measurement and a little arithmetic. A **T-square** and a **ruler** will come in handy.

243. First, measure both dimensions of the print as they will be **after** the print is trimmed to its final size. This print will be trimmed of its borders. Its image area measures 6⅞ × 8⅞ inches. Do not trim the print yet.

245. Carefully indicate these dimensions with **faint** pencil dots on the appropriate edges of the mounting board.

244. The mounting board measures 11 × 14 inches. Subtract the horizontal dimension of the print from the horizontal dimension of the board and divide the result by 2 (11 − 6⅞ ÷ 2 = 2¹⁄₁₆). Then subtract the vertical dimension of the print from that of the mounting board and divide the result by 2 (14 − 8⅞ ÷ 2 = 2⁹⁄₁₆). The results obtained give you the widths of the horizontal and vertical borders, respectively.

246. Use a T-square to draw lines lightly extending several inches **inward** from each corner of the print-mount area.

247. If the print is to be mounted asymmetrically, it will be up to you and your own aesthetic judgment to determine how and where on the board it will be mounted. Once this has been determined, mark the corners of the asymmetrical area lightly in pencil to aid in positioning the print during the mounting procedure.

Dry Mounting

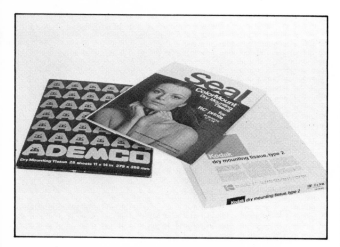

248. If the print is to be mounted in a heated press, a heat-sensitive mounting tissue, appropriate to the type of paper the print has been made on, must be selected. **Ademco Double-Strength Tissue** bonds well to Kodak Resin-Coated papers and melts at a lower temperature than either **Seal RC Mounting Tissue** or **Kodak Type 2 Mounting Tissue.** Since it is possible to melt the plastic-coated prints themselves, this is an operational advantage. However, in the final analysis, local availability may well be the determining factor.

249. Using Ademco tissue, set the thermostat on the mounting press to 185°F (85°C)—or as directed by the manufacturer of the press to achieve this bonding temperature—turn the power switch on, and allow the press to come to the operating temperature. For the Seal or Kodak tissues, set the thermostat for 205°F (96°C).

250. A special tool called a **tacking iron** will make attaching heat-sensitive tissue to the back of the print somewhat easier, although the tip of an electric **hand iron** can be used if need be. Plug either one in; set the tacking iron for **medium** heat (or the hand iron for **wash-and-wear**). Allow several minutes for it to come up to temperature.

251. Place the print, **emulsion side down**, on a clean, smooth surface. Brush off the back of the print. Lay a sheet of heat-sensitive dry-mounting tissue down over the print so that it extends to, or over, all the edges of the print.

253. If the tissue is unaffected, as it is here, increase the heat setting of the iron, allow it to come to temperature, and try the previous step again. If the tissue is melted through, or worse, if the print is burnt or melted, or the emulsion has popped off it, decrease the temperature setting of the iron, allow time for it to cool, and try again.

252. Be sure to test the heat setting of your tacking (or hand) iron with scrap material before you try this on a finished exhibition print. Bring the heated tacking iron (or the tip of the hand iron) into contact with the mounting tissue at the center of the print and apply light to moderate pressure for 1 or 2 seconds. This will cause the tissue to melt immediately under the iron and bond to the back of the print.

254. If the tissue has been properly tacked, it will firmly adhere to the back of the print and show obvious signs of having softened. The emulsion (image) side of the print, however, will be completely unaffected.

255. Turn the print/tissue over and use a straightedge and a blade to trim both at once to the final print dimensions.

257. Put a sheet of **Kraft paper** large enough to cover the print being mounted into the press with the mounting board, close the press for 2 minutes, then open it. (This is done to dry the Kraft-paper cover sheet.)

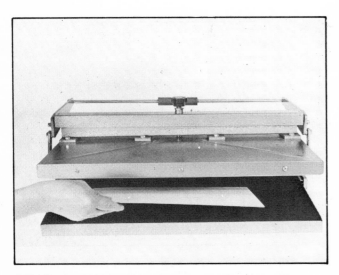

256. Place the board on which the print is to be mounted in the open, heated press. Close the press and leave it closed for 2 minutes. Then open the press, turn the mounting board over and lock the press closed for another 2 minutes, then open it. (The press is closed to heat the mount board and drive moisture from it; it is opened to allow the moisture to escape.)

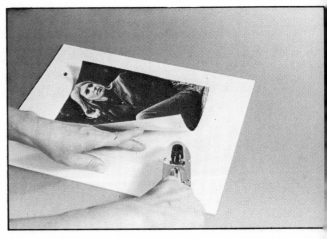

258. Remove the mounting board from the press (leave the Kraft paper in the open press), and carefully place it on a flat surface. Place the print within the guide lines you have previously drawn. Then carefully lift one corner of the print, leaving the mounting tissue undisturbed flat against the mounting board. Use the tacking (or hand) iron to lightly melt the corner of the tissue, thus tacking it to the mounting board.

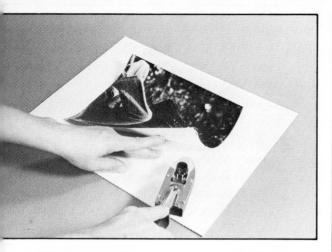

259. Very carefully repeat this corner-tacking operation at the opposite corner. Then carefully tack the remaining 2 corners in place as well.

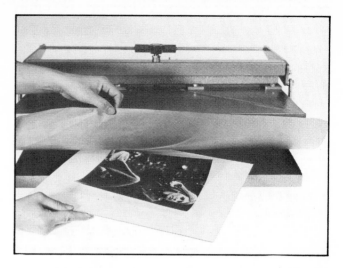

261. Put the mounting board and print on the bottom of the press, under the Kraft paper.

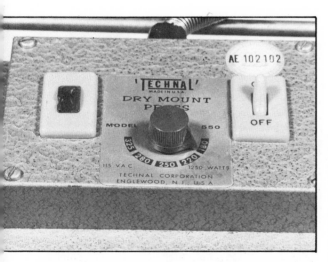

260. Check the indicator light or thermometer on the mounting press to be sure the press is at the proper operating temperature. On this Technal press the indicator lamp goes **off** when the proper temperature has been reached.

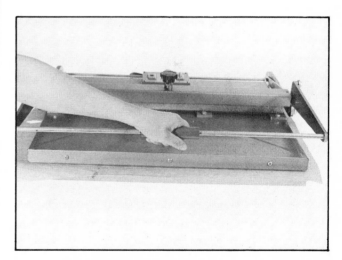

262. Close and lock the press. If the press is improperly set, this operation will be either too easy or too hard to perform. If it is, set the pressure-adjusting controls according to the press manufacturer's instructions to correct the situation.

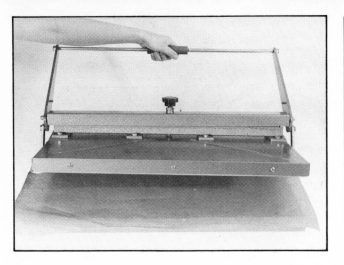

263. After 10 seconds has elapsed, open the press and leave it open for 10 seconds. Then repeat the procedure—close for 10 seconds, open for 10 seconds—twice more. This heats the print, tissue, mount board, and Kraft paper to drive out moisture, but should not heat the materials sufficiently to melt the mounting tissue.

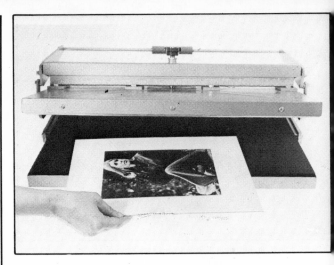

265. After 1 minute has elapsed, open the press, remove the mounted print, and immediately place it on a clean, flat surface.

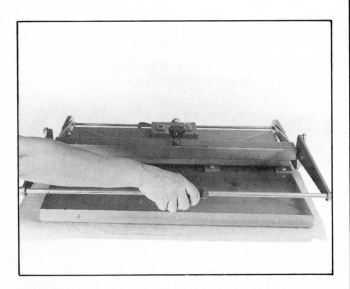

264. Finally, close and lock the press for 1 minute (or longer if the mount you are using is thick).

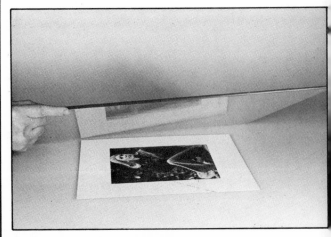

266. Quickly place a **flat, thick plate** of clean, smooth, cool glass or metal over the print.

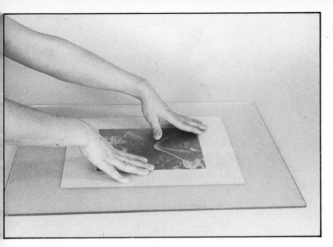

267. Press down on the top of the glass or metal plate. This keeps even pressure on the print as the thermoplastic tissue cools and solidifies, preventing the print edges from curling off the mount. Keep pressure on the glass or metal plate for 1 minute.

269. If the print is to be mounted with a **pressure-sensitive adhesive sheet,** begin by following the procedure shown in Figures 242–247 or, as in this case, where the image has been centered on the sheet of printing paper with wide borders, mount the print flush with the edges of a board.

268. Remove the glass and check the flatness of the mounted print. If any edges have risen, they can be reheated for a minute in the closed press and then pressed under the glass to get them to adhere. This operation may have to be repeated several times with certain combinations of plastic-coated papers and dry-mounting tissues.

270. Scotch Brand Positionable Mounting Adhesive Sheets No. 567 offer a characteristic which, to the best of my knowledge, is unique among pressure-sensitive materials: They permit the print being mounted to be repositioned if you make an initial positioning error. They also allow the print to be peeled from the mount with relative ease after mounting has been completed. Each sheet has 2 coverings. The printed covering is called the release paper. The unprinted covering is called the carrier sheet.

271. Place the print to be mounted, **emulsion side down,** on a clean, smooth surface. Brush the back of the print free of any foreign matter.

273. Place the print to be mounted, **emulsion side down,** on the release paper. Position the carrier sheet over the print back with the tacky side down. Be sure the final position of the carrier sheet brings it to, or over, all the edges of the print being mounted.

272. Place the adhesive sheet on a clean, smooth, flat surface with the printed release paper down. Peel the carrier sheet away from the release paper.

274. Use the **squeegee** supplied with the adhesive sheets (or a roller if you prefer) to apply firm pressure as you stroke it, in an overlapping pattern, across the entire surface of the carrier sheet. Stroke the entire sheet first in a horizontal direction, then in a vertical direction.

275. This is the time to use a blade and a straightedge to trim the print being mounted to its final dimensions. If this print were being cut to its border and mounted on a board, it would be trimmed as shown. However, as mentioned earlier, this print will be mounted flush with the edge of the board, so no cutting is necessary.

276. Lift the print and carefully separate the carrier sheet from it. As you do, note if the adhesive is evenly transferred from the carrier sheet to the back of the print. If it isn't, repeat the step shown in Figure 274.

277. Place the mount board on a flat surface. Brush the surface of the mount board to remove any foreign matter. Position the adhesive-coated print, **emulsion side up**, within the guidelines previously drawn, or aligned with the edges of the board, as shown here. If you make a mistake in placing the print on the board, you may reposition the print until the proper alignment is achieved.

278. Place the release sheet, printed side up, over the print and use the squeegee or a roller to stroke the entire surface of the print in overlapping strokes, in both the horizontal and vertical directions.

279. Once you have mastered the seemingly tedious and complicated but actually rather simple steps involved in print mounting, you will find the results to be well worth the effort.

280. While mounted prints look considerably better than unmounted ones, framed mounted prints look best of all; and after all, **this entire book has been dedicated to improving your image**.

Afterword and Acknowledgments

I'd like to express my thanks to all of the many people who helped to make this book a reality, but there are simply too many of them for me to be able to do a decent job of it and still manage to keep this from looking like the Manhattan phone directory. May it suffice, then, for me to say thank you to Jim Hughes, the editor of *Popular Photography's How-To Guide*, for showing his incredibly good taste by purchasing first serial rights to this book, and presenting it, in its entirety, in his fine magazine. Many thanks too to the patient and totally indestructible art director of that excellent publication, Tom Ridinger, for making it all fit and look good to boot. And still more thanks to the editorial staff of the *How-To Guide*—Steve Pollock, Carol Carlisle, and Debbie Goldie—for managing to deal with all the thousands of pieces and parts that went into the manuscript, and then managing to get them all back to me, in good repair, so that I could make this book out of them. My appreciation goes to the several manufacturers and distributors of photographic supplies, all of whom were kind enough to provide many of the props used in shooting the illustrations. More thanks go to Gloria Litowsk for her gracious permission to use several of her portfolio shots as illustrations here. And finally, my heartfelt thanks and appreciation to my wife Gardy, for all of her patience, help, modeling, and understanding, without any one of which this book would have been completely impossible.

PT 123
125